MW00619571

IMAGES
of America

MAPLE SUGARING
IN NEW HAMPSHIRE

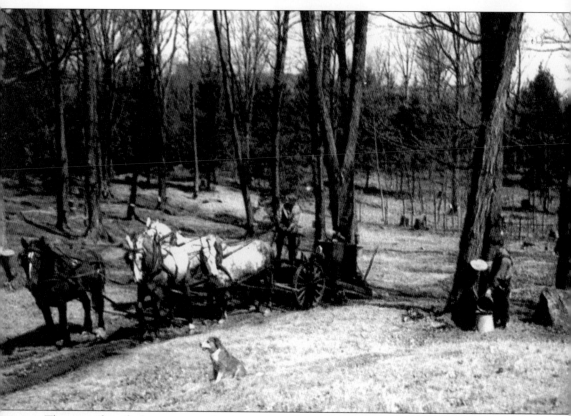

These unidentified men are gathering sap in the early 1900s. The four- to six-week maple season in New Hampshire usually begins in late February in the southern part of the state and ends in mid-April in the far north. Below-freezing nights and daytime temperatures in the 40s are ideal for good sap runs. When there is little snow or a late snow cover during the winter, the frost penetrates deeper into the earth; it therefore takes longer for tree roots to thaw and the sap to run. If the weather warms too quickly, the maple season will be brief. Sap usually stops running when the buds appear on the branches.

IMAGES
of America

MAPLE SUGARING
IN NEW HAMPSHIRE

Barbara Mills Lassonde

ARCADIA

Copyright © 2004 by Barbara Mills Lassonde
ISBN 0-7385-3686-5

First published 2004

Published by Arcadia Publishing,
Charleston SC, Chicago IL, Portsmouth NH, San Francisco CA

Printed in Great Britain

Library of Congress Catalog Card Number: 2004108956

For all general information, contact Arcadia Publishing:
Telephone 843-853-2070
Fax 843-853-0044
E-mail sales@arcadiapublishing.com
For customer service and orders:
Toll-free 1-888-313-2665

Visit us on the Internet at www.arcadiapublishing.com

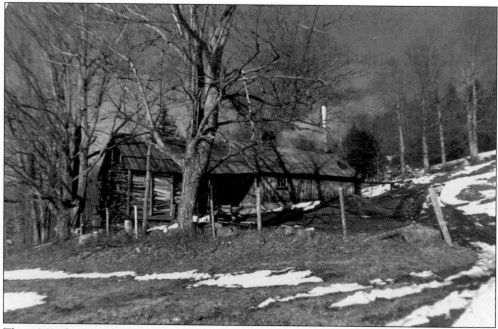

This 1962 photograph shows the Johnson Farm sugarhouse in Monroe. The author spent each spring gathering sap at this farm owned by her grandfather and later by her uncle, then by her cousin. It was once believed that allowing cattle to roam through the maple orchard was good for the trees, until foresters realized that grazing cattle prevented new trees from developing and that their hooves compacted soil around the tree roots.

CONTENTS

ACKNOWLEDGMENTS

This book would not have been possible without the cooperation of Charlie Stewart and many other maple producers, the New Hampshire Maple Producers Association, the Farm Bureau of Merrimack County, and the New Hampshire Department of Agriculture, who so generously shared their treasured photographs. For this I express my sincere gratitude. Some of the historical facts were gleaned from *Reynolds, Maple and History fit for Kings,* by Lynn H. Reynolds, and *Sweet Maple,* by James M. Lawrence and Rux Martin. I thank those authors for their valued contributions. I also thank my husband for his encouragement and assistance.

INTRODUCTION

Long before the first European settlers arrived in America, native northeastern tribes set up camp in the maple orchards each spring and tapped the sugar maples. They made enough maple sugar to use for bartering with other tribes and to sweeten their own food for an entire year. For probably hundreds of years, they used the same crude method of boiling down the slightly sweet clear sap. Tribal women collected the sap and poured it into long wooden troughs that the braves had hewn with their tomahawks. The women then dropped red-hot stones into the watery sap to make it boil. When most of the water had evaporated, they stirred the thickened syrup with wooden paddles until it dried and became granular. There is no doubt that early sugar was flavored and darkened by soot and other debris.

Due to the lack of written history, no one knows when the Native Americans first tapped a tree or how they learned to make the sugar, but they told early settlers that they had been making it for a long time. Because the Native Americans were so in tune with nature, they probably observed squirrels biting into tree limbs and drinking the sap. One legend tells of a squaw needing water to boil venison for the evening meal. Sap had dripped into a container beneath a maple tree, and thinking it was water, she cooked the meat in it. The venison was the best her husband had ever tasted and thus began the art of maple sugaring.

Native Americans taught the early white settlers how to make maple sugar, and it was not long before the newcomers began using iron kettles over an open fire. The method of boiling sap had improved and remained at that level for another 200 years.

Pres. Thomas Jefferson believed that maple sugar would salvage the American economy, and he encouraged everyone to plant sugar maples to secure the future. George Washington agreed, and both men planted hundreds of the trees at their Virginia homes. The Southern climate proved too warm for the cold-loving trees, and they did not flourish. Washington and Jefferson's dreams of producing their own maple sugar were dashed.

During the Civil War, the supply of cane sugar from Southern states was halted, and the Union army called for large amounts of pure maple sugar for the troops. Northern farmers and Native American tribes alike rallied and produced huge amounts of sugar. They were paid for their product after the fighting ended in 1865. After the war, flat pans were developed and it became obvious that sap boiled down much more quickly in shallow containers with wide openings at the top. This was the first major improvement in maple sugaring in two centuries. Tin cans were first used as food containers in the United States during the Civil War, and soon after that, farmers began using them for maple syrup. The popularity of the syrup grew steadily.

From the mid-1700s, an influx of English settlers arrived, and they began clearing the forests, declaring the trees a hindrance to farming. Northern sugar makers knew the value of their maples, and in the mid-1800s, the cry to "save your maples" reverberated throughout the Northeast. By the late 1800s, New Hampshire's hills and mountains were nearly denuded, but many private farms had kept their maples. With the designation of national forests and controlled logging, new growth appeared, and the granite hills were again blanketed with trees.

In the late 1800s, evaporator pans were improved upon by sectioning them off and later by making a connecting back pan with flues. This flue design was originally created by bending the English tin over a section of railroad track. The flues increased the heating area, boiling the sap more quickly. Wood-fired furnaces, or arches, were designed to hold the pans. This equipment had to be protected from the weather, so sugarhouses sprang up throughout the maple belt.

The 1900s brought a myriad of inventions and dramatic improvements in maple equipment, especially during the latter half of the century. Now, with the use of plastic tubing, automation, and faster means of evaporation, one person can produce as much maple syrup as ten men did a century ago. Even with all of these new inventions and improved filtration, the flavor of real maple syrup has not changed, and the basic principle of making maple syrup remains the same—remove most of the water. Pure maple syrup is still a natural product with no additives or preservatives. New Hampshire maple producers look forward to tapping their trees each spring and providing the world with a unique and delicious food that is made primarily in this one small corner of the world.

One

Primitive Methods and Early Innovations

1700s–1920

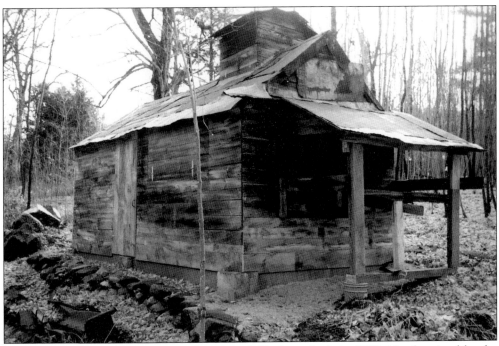

A portion of this Bolduc farm sugarhouse in Gilford was built in 1779. Nearly ruined by the elements, it was lovingly restored in 1990. Although it is no longer used as a sugarhouse, it is on display for visitors to see and houses an assortment of old maple equipment.

Spiles (or spouts) and hollowed-out logs like these were used from *c.* the 1600s through the early 1800s. A hole was drilled in the tree and the spile inserted. Sap flowed through the hollowed spile and dripped into the log on the ground beneath. The sap was then collected and boiled down in long wooden troughs and later in large cast-iron kettles.

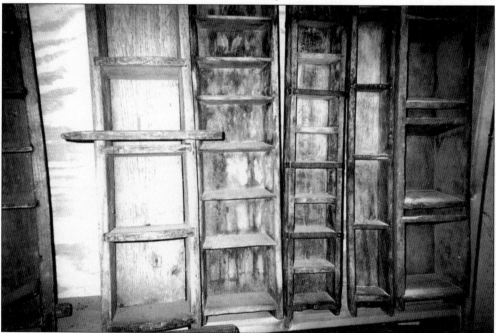

These wooden molds were used by early settlers to make blocks or cakes of maple sugar, which were then wrapped in cloth and stored for future use or shipped to larger cities for sale. In 1788, maple sugar became the moral choice for those who believed cane sugar was a product "washed with the tears and blood of slaves."

Wooden sap buckets were used from the 1700s into the early 1900s. With the appearance of the Maple Moon, the first full moon of early spring, Native Americans and early settlers knew it was time to tap the trees. Besides making maple sugar, some colonists made the popular sap beer from fermented sap and yeast.

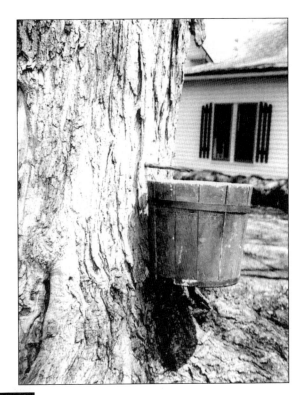

Hand-carved sugar molds like these were used throughout the 1700s, 1800s, and early 1900s. This assortment includes a coffin-shaped mold, which was probably used for funeral candy. These molds, made by individual sugar makers, were each as unique in design as the person who carved them.

11

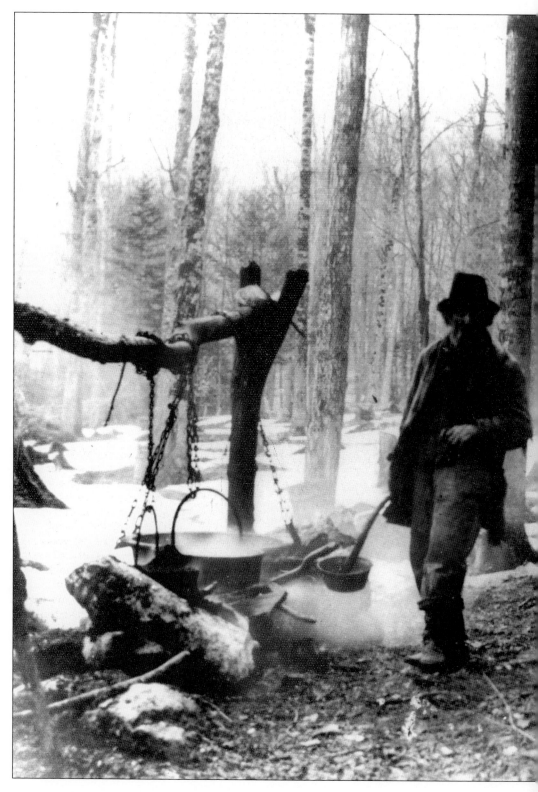

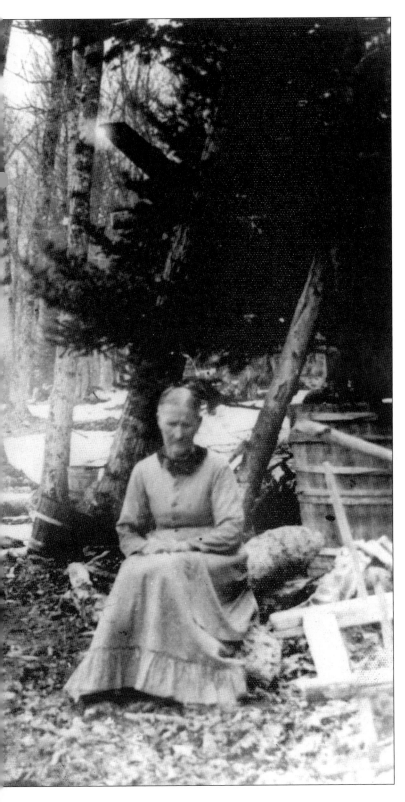

For over 200 years, maple sap was boiled outside in large cast-iron kettles over an open fire. Well-to-do sugar makers used a series of three open kettles, each one smaller than the previous. As the boiling progressed, the sap was poured into the next smaller kettle and was finished off into sugar in the smallest kettle. Tubs or barrels like the one on the right in this view were used to store sap. The photograph was taken in the 1880s in the town of Sugar Hill by the Reverend S. S. Nickerson, who owned the first camera in the area.

13

This large wooden tub is approximately five feet in diameter and about four feet high. Similar to the one in the previous photograph, it was used in the 1800s to hold sap until it could be boiled down in iron kettles. The sled on the right was used to haul firewood, wooden buckets, or other maple equipment. Wooden containers were swelled ahead of time so the sap would not leak out.

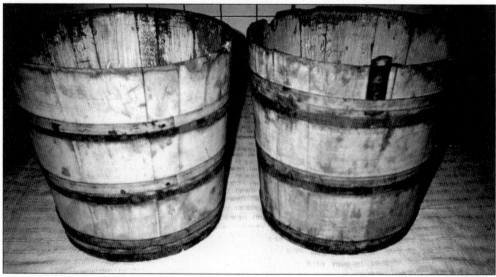

Tree nails were used to hang wooden sap buckets like these ones, made by the Enfield Shakers. Sap dripped into the buckets and was later boiled into sugar. Maple sugar was the primary sweetener in the northeastern United States until the 1880s. Even Thomas Jefferson used it in his morning coffee and served it to distinguished guests at the White House and Monticello.

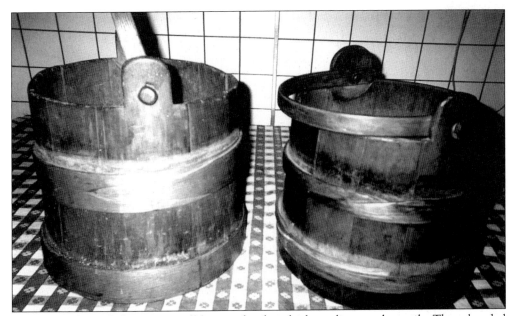

New Hampshire Shakers were well known for their high-quality wooden pails. These banded and notched hoop pails were made by the Shakers in Enfield and were used to gather sap from the buckets on the trees. In the early days, maple trees were so plentiful that nearly everyone who owned property made their own sugar.

These primitive handmade sugar tubs were used in the 1800s. The metal "sugar devils" were used to loosen the hardened sugar. Many believed maple sugar was more pure than cane sugar because it was produced in late winter, when no insects were active to pollute it.

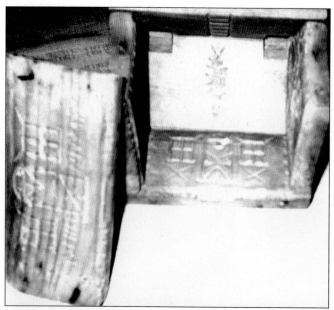

Some sugar molds included a great amount of detail, such as this cabin mold, complete with windows and a door. This mold was assembled and turned upside down; the hot syrup was then poured into the mold. After the syrup cooled and hardened, one side of the mold was removed so that the sugar cake could be dislodged.

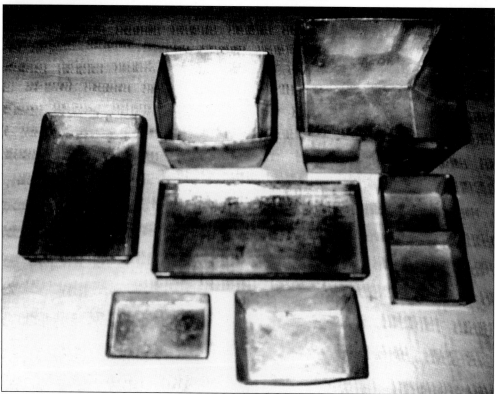

Tin sugar molds made by local tinsmiths were widely used in the 1800s. In 1863, the Union army was desperate for sugar for the troops because the supply of Southern cane had been halted. The army called for one-pound blocks of pure maple sugar individually wrapped in waxed cheesecloth. Many New Hampshire farmers and Native American tribes supplied sugar to the troops but had to wait until after the war for payment.

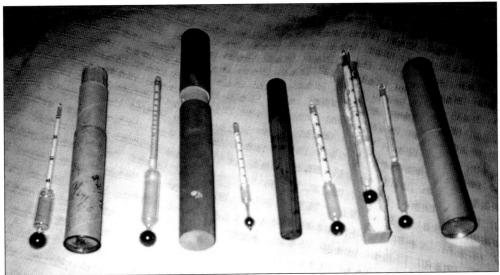

These thermometers with wooden cases were manufactured by the A. J. Dodge Company of Peterborough. They were used by sugar makers in the 1800s before hydrometers became popular. Maple sap becomes syrup at approximately 219 degrees and sugar at approximately 237 degrees. Because these temperatures vary with the altitude and barometric pressure of the day, hydrometers became the preferred instrument to test for doneness.

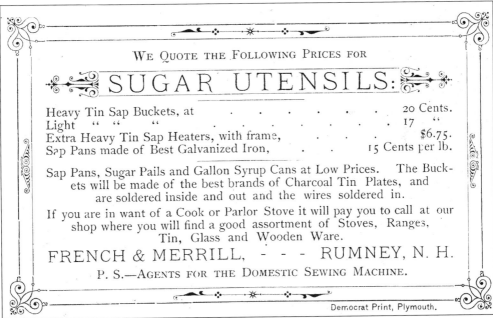

WE QUOTE THE FOLLOWING PRICES FOR

SUGAR UTENSILS:

Heavy Tin Sap Buckets, at 20 Cents.
Light " " " 17 "
Extra Heavy Tin Sap Heaters, with frame, . . . $6.75.
Sap Pans made of Best Galvanized Iron, . . 15 Cents per lb.

Sap Pans, Sugar Pails and Gallon Syrup Cans at Low Prices. The Buckets will be made of the best brands of Charcoal Tin Plates, and are soldered inside and out and the wires soldered in.

If you are in want of a Cook or Parlor Stove it will pay you to call at our shop where you will find a good assortment of Stoves, Ranges, Tin, Glass and Wooden Ware.

FRENCH & MERRILL, - - - RUMNEY, N. H.

P. S.—AGENTS FOR THE DOMESTIC SEWING MACHINE.

Democrat Print, Plymouth.

In 1880, New Hampshire's maple syrup production neared its peak of over 345,000 gallons. At that time, the price of cane sugar became equal to the price of maple sugar, and the demand for maple dropped. Today, the state's maple production is approximately 90,000 gallons. French and Merrill Company in Rumney operated during the 1880s, selling maple equipment and other items.

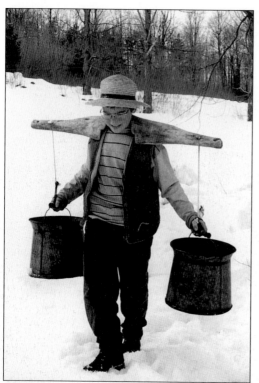

Nathan Bundy of Lebanon appears to enjoy hauling sap as his ancestors did in the 1800s. The ability of the sugar maple to impart gallons of sap year after year is unmatched in the plant kingdom. In the early years, maple sugar was commonly used in the North because it was plentiful and inexpensive.

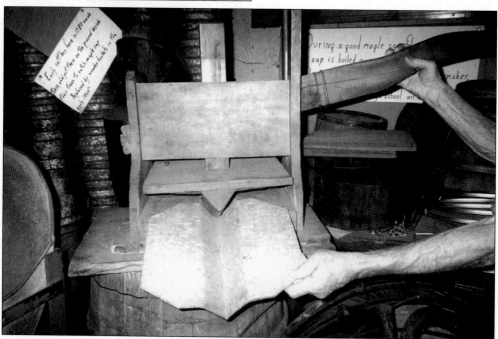

This handmade press was used to form a ridge in sap bucket covers so they would fit over the spiles protruding from the trees. A snug-fitting cover reduced the amount of debris and rainwater entering the bucket. The first metal sap spout was developed in 1860, with metal pails and lids following soon after.

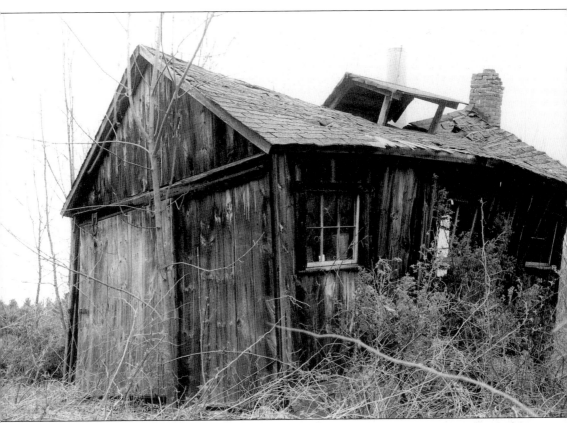

This sugarhouse on the Noble Farm in Amherst was built c. 1800 and was originally used as Mr. Hubbard's blacksmith shop. It was converted to a sugarhouse c. 1975 but has since been ravaged by time and the elements. As more New Hampshire farms are discontinuing operations and farmland is being developed, the once sturdy buildings that long graced the fields and forests are deteriorating. As these historical structures crumble, so do our ancient farming traditions. Through their work publicizing and educating the public on maple sugaring, Granite State maple producers are trying to keep this craft alive.

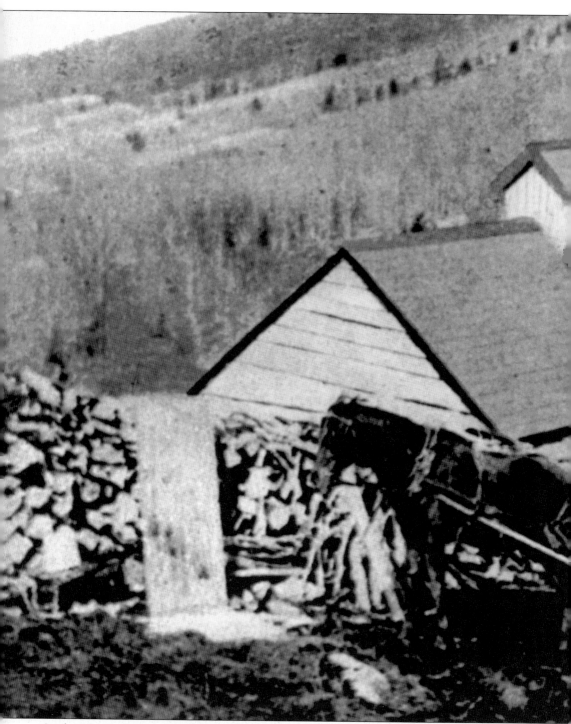

At the Mount Agassiz Sugarhouse in Bethlehem, blocks of maple sugar wrapped in cloth are loaded onto the gathering tub to be hauled back to the farm. In the years before tin cans were available, maple syrup was further boiled down into maple sugar for easy storage—hence the term maple sugaring. Nearly all farmers made maple sugar, as the sap ran during a season when

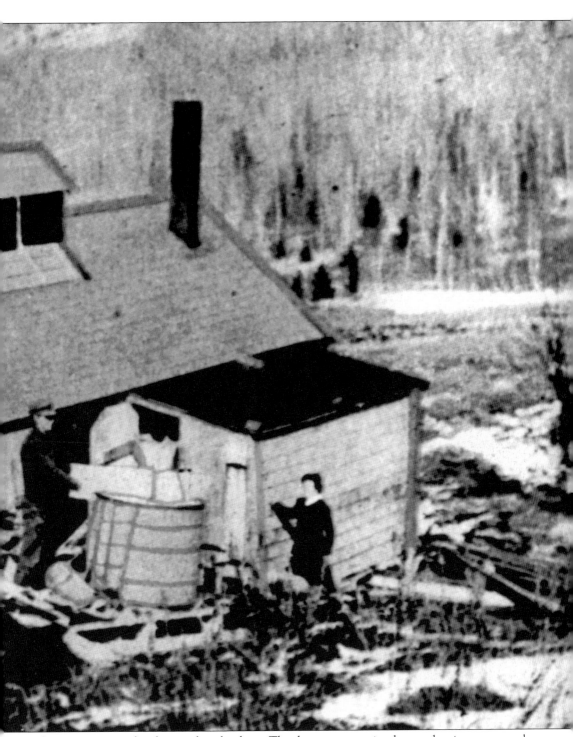

there was not much other work to be done. The days were growing longer, but it was too early for plowing and planting. Maple sugar provided an income to those families who lived mostly off the land.

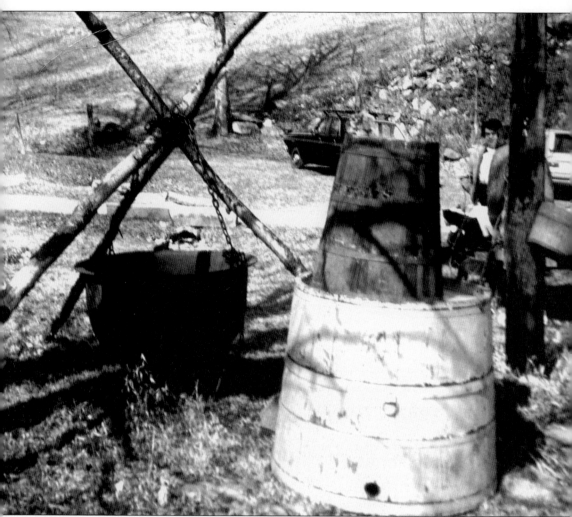

This maple-sugaring equipment from the 1800s is owned by David Clark. Sap dripped from the tree into the wooden sap bucket on the right and was poured into the gathering pail and then into the collection tub. The cast-iron kettle, many of which were made at the Franconia Iron Works, was used to boil the springtime sap. Because the British had few trees left for making potash, New Hampshire settlers used these kettles during the summer to make large amounts of the ash. This was sold to the British for manufacturing soap, gunpowder, glass, fertilizer, and bleach. In late fall, the kettles were used to scald slaughtered pigs. The wooden containers were likely used for water during the off-season.

By 1862, sugar makers found that flat-bottomed pans were better than kettles for boiling sap because the larger surface area increased the rate of evaporation. Later, pans were partitioned off with openings at opposite ends of each section, allowing the liquid to move from one section to the next. As the sap boiled and thickened, it traveled in a zigzag pattern through the pan. This company was one of the early manufacturers of evaporators.

This is the front of an arch made by the Granite State Evaporator Company of Marlow in the late 1800s or early 1900s. This company operated from 1895 to 1917, first manufacturing fruit evaporators and then building sap evaporators from 1900. Arches, or furnaces, were built to hold the evaporator pans and to keep a roaring fire beneath them. Later, a system of two connecting evaporator pans was developed and is still used today.

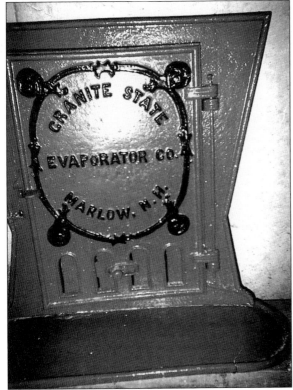

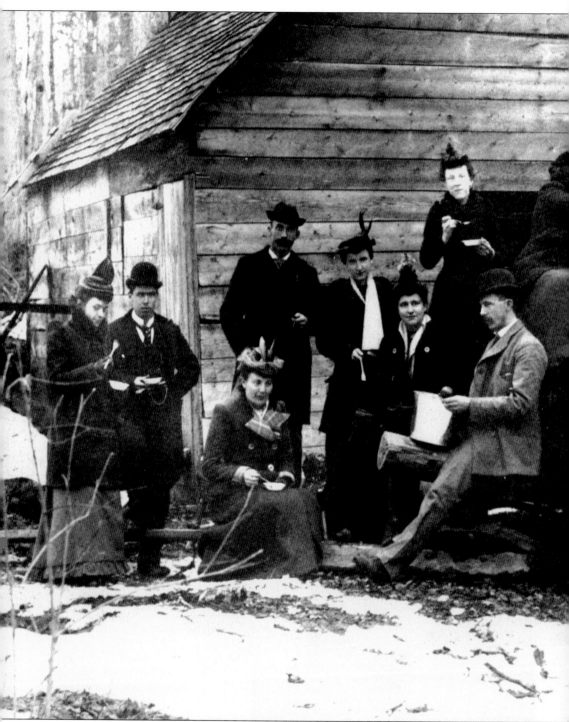

This sugaring-off party in 1895 in Lancaster shows couples enjoying the sweet taste of sugar on snow. Sour pickles were often served to counteract the sweetness of the sugar so more of the sweet treat could be eaten. The large flat pan on the right was probably used to boil the syrup. Sugar on snow is made by boiling syrup to 233 degrees; it is then drizzled over clean snow, where

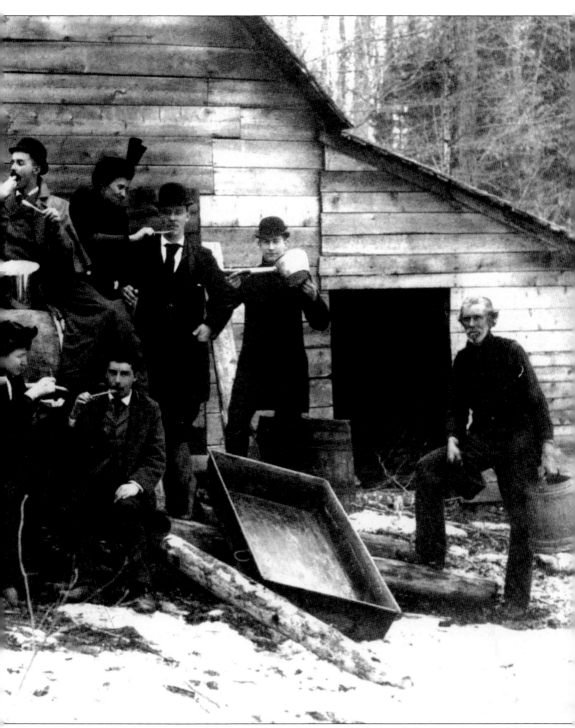

it immediately hardens into a taffy. Sugaring-off parties were traditionally held at the end of the sugaring season and gave folks an opportunity to socialize after a long winter of isolation. Many maple producers still hold these parties for their friends and relatives.

These wooden troughs, when hooked end to end, were used to carry sap from the maple orchard to the sugarhouse in the late 1800s and early 1900s. Sap collected from the trees was poured into a central collection tub or dumping station. It then ran through the troughs to the holding tub at the sugarhouse. Wooden troughs were later lined with zinc.

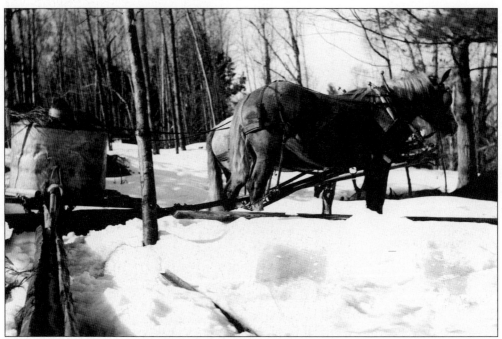

Here, sap flows from the gathering tank through a hollowed log into the holding tank at the sugarhouse. Gathering and holding tubs were made of wood, and tanks were made of metal. Due to many factors, maple production was declining when this picture was taken in the early 1900s.

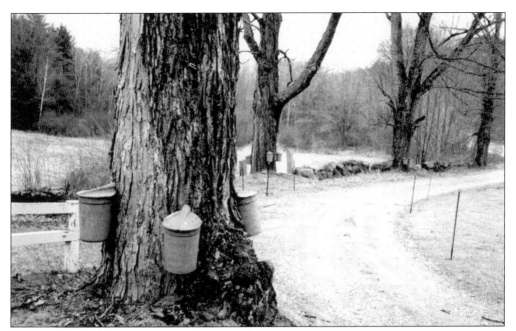

Marie Chase of Amherst took this photograph of her sap buckets made in the early 1900s. On average, one tap in a sugar maple will yield approximately 10 gallons of sap, which will boil down to about one quart of syrup. Other maples such as red and box elder can also be tapped, but the sugar content in their sap is lower and requires more sap to make one gallon of syrup.

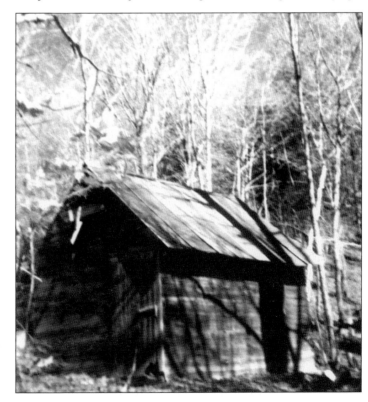

Ed Brown's Sugarhouse in the Canadian border town of Pittsburg, was built in 1914. It was continuously used until the late 1940s and again for a couple of years in the 1950s. Although the building is rather dilapidated, it still stands thanks to repair work by Lindsey Gray, a local maple producer.

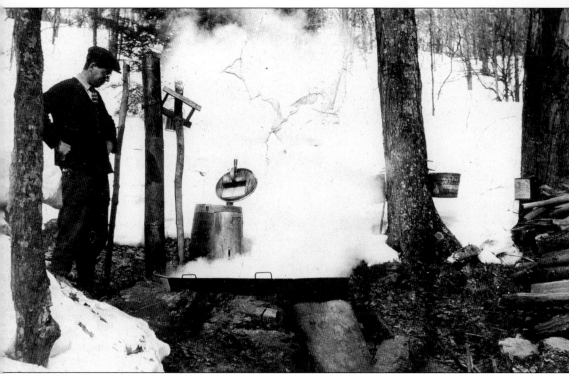

Leroy Clark of Acworth watches sap boil in his flat evaporator pan in 1917. It is important to keep a close watch on boiling sap, especially when it nears the syrup stage and can burn on the pan. Sap must be added periodically to maintain a certain level of liquid in the pan. Before sugarhouses became commonly used, most people boiled sap in kettles or flat pans in the woods. Some used crude lean-tos to protect them from bad weather; others boiled out in the open. The Clark family has been making maple products since 1893 and still boils with wood.

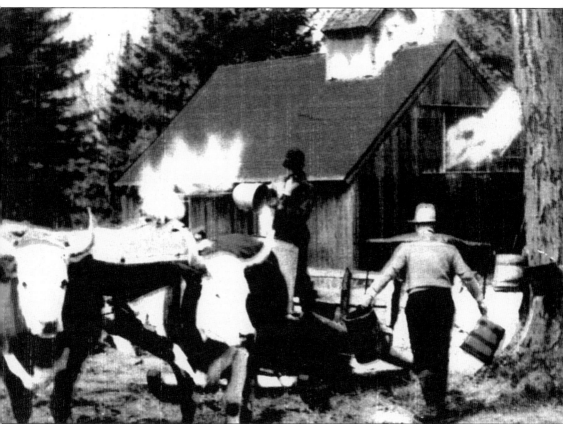

This picture shows steam billowing from the Homestead Sugarhouse in Sugar Hill in the early 1900s as Len Wessels and Will Dexter collect sap. Day and night for up to six weeks each year, the sugar maker's life revolves around the weather and the unpredictable sap runs. When the sap runs, the sugar maker must boil and everything else must wait. Most of the steam from the boiling sap escapes through the cupola atop the roof. Seldom is it seen emanating from other openings as in this picture, which was probably hand colored in Germany.

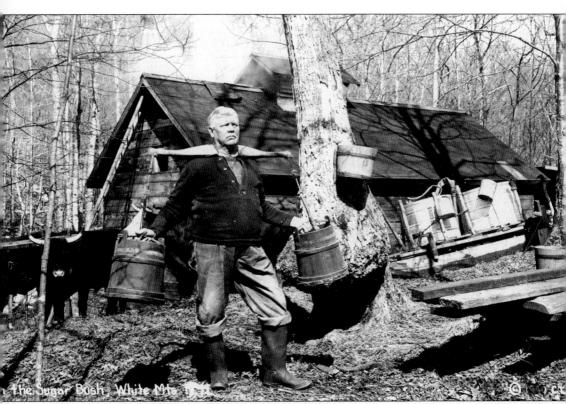

The Sugar Bush, White Mts.

Here at Nanson Smith's sugarhouse in Hebron *c*. 1900, Nanson's father goes out to gather more sap. Sap from the tree buckets is poured into the collection pails and then carried to the sugarhouse, dumping station, or gathering tank. Native Americans used birch bark containers for gathering sap. Then, for over 200 years, wooden pails were used. When metal pails were first introduced in the late 1800s, it took decades before most frugal Yankees had converted to them. Metal pails were lighter in weight than the wooden ones. They were also easier to clean and did not need swelling.

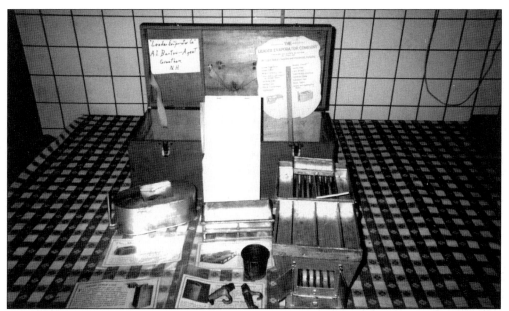

This salesman's kit for the Leader Evaporator Company was used *c.* 1900. The items are, from left to right, a miniature gathering tank, a holding tank, a bucket and spiles, and a miniature evaporator with removable pans. Trying to sell these items to New Hampshire sugar makers was not an easy task, but the metal equipment eventually caught on. One salesman drove a Model A Ford truck from one sugarhouse to the next.

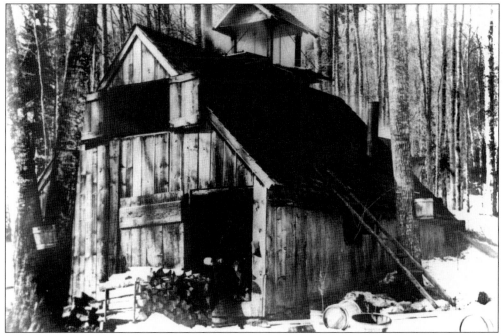

In the spring of 1900, Len Bowles's sugar camp was a busy place. The cupola atop the building allows the steam to escape. Sugar camps are usually larger than sugarhouses, and they are equipped with cooking and sleeping facilities so the maple producer can live there during the four- to six-week maple season.

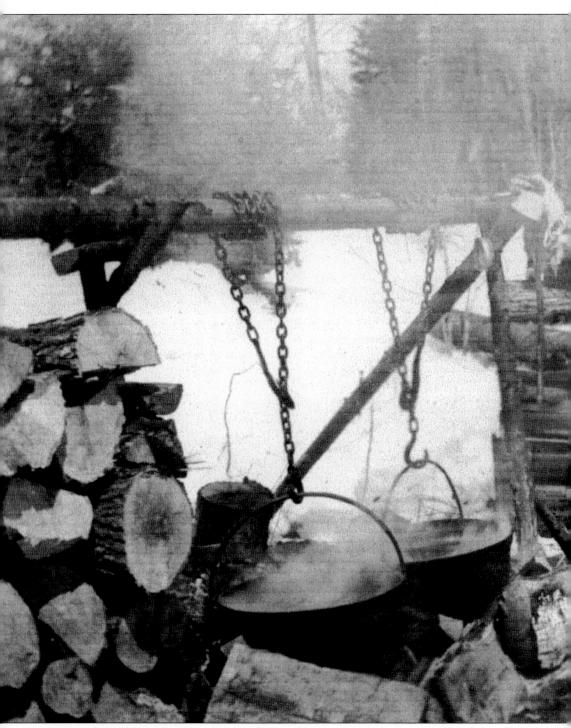

Boiling down the sap requires plenty of firewood, as it takes approximately 40 gallons of sap to make one gallon of maple syrup. Although boiling outside was common in the 1800s and early 1900s, a few progressive sugar makers built lean-tos or sugarhouses for shelter during cold or stormy weather. This picture, taken in April 1934 in the Plymouth area, shows two neighbors

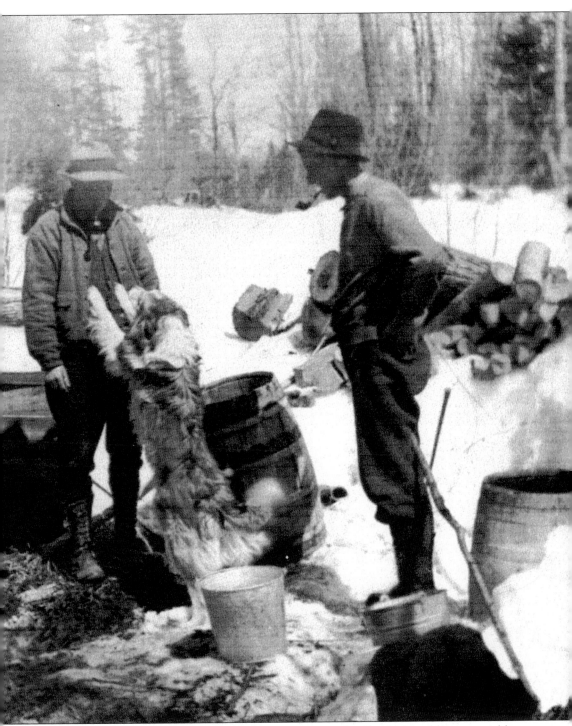

catching up on the news. Sugaring time always seems to rekindle old friendships as neighbors chat while the sap boils. The sight of steam rising in the woods and the smell of maple wafting across the valley draws people to the source where a friendly welcome and pleasant conversation keeps them there for a while.

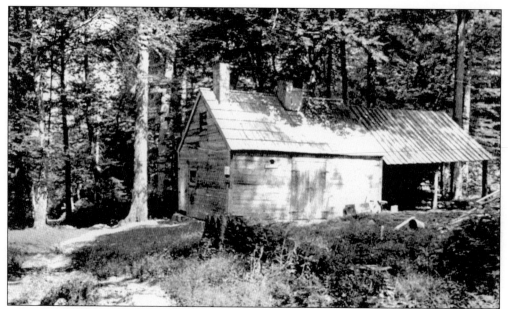

In the late 1800s, maple sugar was used to flavor chewing tobacco, which became a huge market for sugar makers for over 40 years. With the invention of evaporator pans and arches, sugarhouses were built to protect the equipment and to keep the sugar makers warm and dry while they boiled. This picture of Turner's Sugarhouse in Bethlehem was taken c. 1900.

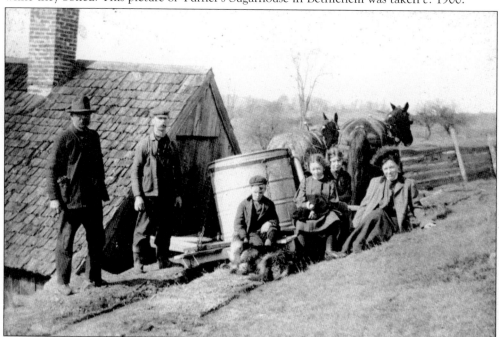

Two generations of Clarks welcomed these four young people on the right from Bath Upper Village to Clark's Sugarhouse in Landaff in the early 1900s. Maple producers still welcome visitors to their sugarhouses during the maple season and willingly demonstrate how maple syrup and sugar are made. Since 1994, New Hampshire producers have held a New Hampshire Maple Weekend in late March, when people are encouraged to visit a sugarhouse.

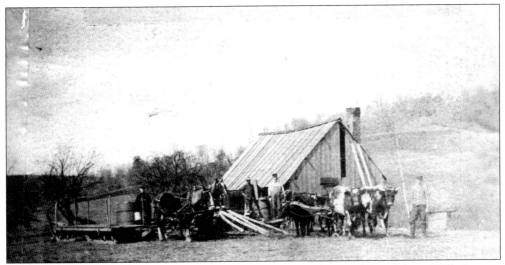

At Gowen's Sugarhouse in Acworth in 1913, Harry Gowen and his father, Will Gowen, flanked by two unidentified helpers, pose with barrels of sap on their ox-drawn sleds. This appears to have been a winter of little snow. The amount of snowfall does not affect the quantity of sap a tree yields, but the amount of rain during the summer can.

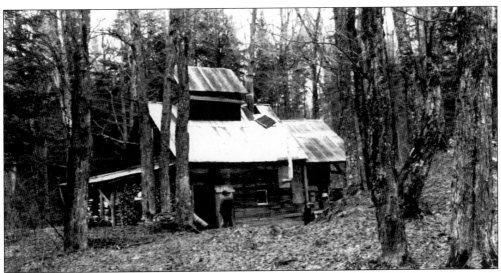

In the early years, sugarhouses were usually built at a low point in the midst of the maple orchard, so those carrying a full load of sap had easier traveling downhill. Gray's Sugar House in Clarksville, built in 1921, is still being used and is surrounded by a well-maintained maple orchard.

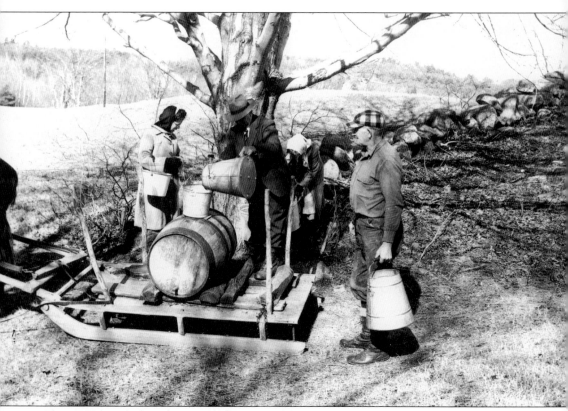

These unidentified workers are helping to collect sap. The sled is drawn by a single horse. During New Hampshire Maple Weekend, visitors to some sugarhouses have the opportunity to go out into the woods and help collect sap. Many sugarhouses are open to visitors throughout the maple season when they are offered tours of the sugarhouses and explanations of the maple-sugaring process. Maple sugaring dates back to before recorded history, but it is believed the Native Americans made sugar for hundreds of years before the first European settlers arrived.

Two
ERA OF CHANGE
1921–1970

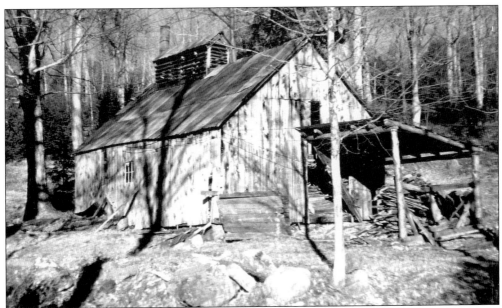

This sugarhouse at the Clark Farm in Acworth was used from the 1920s through the 1940s. The Clark family has been keeping detailed records of each sugaring season for 45 years, and ancestors kept occasional records as far back as 1911. David Clark is the fifth generation to make maple syrup on the property.

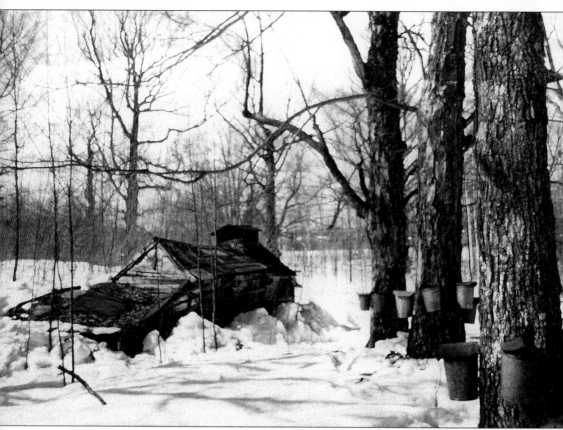

The original Bolduc Farm sugarhouse in Gilford was built in 1779 and has been restored several times over the years, most recently in 1990, shortly after this photograph was taken. Well-kept records prove that maple sugar and syrup have been made on the property every single year since 1779. The Bolducs' enormous trees have a high sugar content in their sap, earning them the title of a super-sweet sugarbush, or maple orchard. It was once judged the sweetest in Belknap County. Some of these trees were tapped before George Washington became president and are still being tapped today.

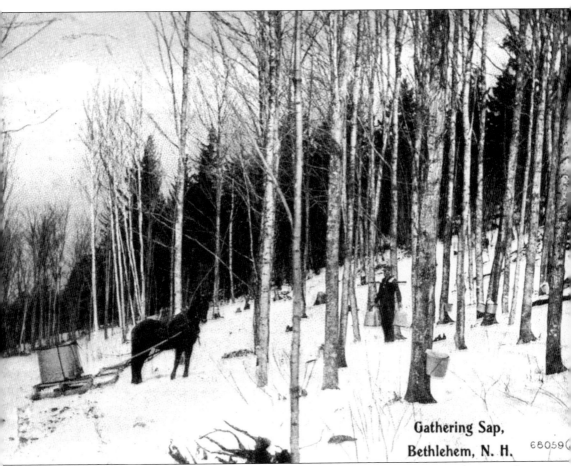

Gathering Sap,
Bethlehem, N. H. 680596

This picture of a man gathering sap in Bethlehem was taken c. 1910. Some large maple operations maintained warming huts in various locations throughout the maple orchards. Each of these huts had a wood stove and a stack of dry firewood so tapping crews in the area could warm up on cold winter days. Sugar makers who tapped thousands of trees often had to begin tapping before the warmer sugaring weather arrived, as they did not want to miss the first good runs of sap. Many old-timers cherish syrup made from the first run because it is usually the lightest in color and has the most delicate flavor.

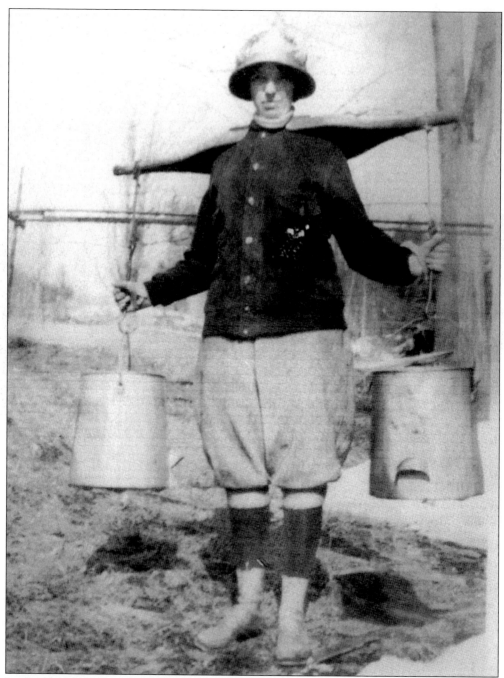

In the Plymouth area, an unidentified woman models a sap yoke with gathering pails. When the Great Depression began after the stock market crash in 1929, many banks were closed, and savings accounts disappeared or were frozen. No money could be borrowed, and those who sold products likely could not receive payment. Everyone was affected. In order to pay their taxes, many farmers were forced to sell portions of their land to those few who could afford to buy it. The economic decline brought a serious reduction in commercial maple production. In New Hampshire, syrup output dropped from 273,858 gallons in 1910 to 92,000 gallons in 1930.

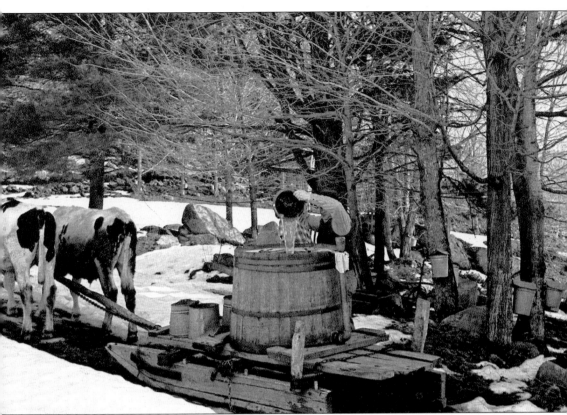

Strong oxen hauled sleds with sap tubs for over two centuries, and some maple producers still use oxen today. A wooden sap receptacle was called a tub, and a metal receptacle was called a tank. After the stock market crash of 1929, Americans struggled just to survive. Farmers were fortunate that they could live off their land, raising feed for their livestock and plenty of food for their families and others. Maple-sugaring operations diminished because there was little market for the product. The average price of syrup dropped from nearly $2 per gallon before the crash to $1. Even at that price, maple syrup was a luxury few people could afford.

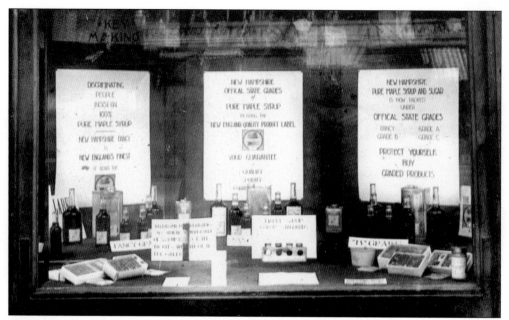

This 1930s New Hampshire Department of Agriculture display of maple products in Concord shows the various grades of syrup and candy, and it encourages consumers to protect themselves by purchasing graded products. The sign on the upper left states, "Discriminating people insist on 100 percent pure maple syrup. New Hampshire Fancy is New England's finest."

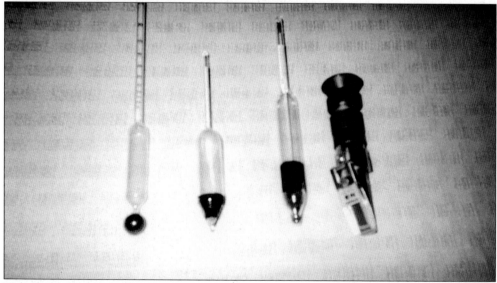

These utensils made by the Charles Wilder Company of Peterborough were used to measure the density of maple syrup. The items are, from left to right, a sucrometer, the earliest measuring utensil; an early hydrometer, which floated in the syrup; a hydrotherm, which also floated in the syrup and was like the hydrometer but had a built-in thermometer; and a refractometer, which determined the sugar content by measuring the amount of light refracted through the syrup.

This thermometer spoon from the 1900s was not widely used but was a handy tool for the sugar maker who owned one. The temperature of the liquid in the bowl of the spoon registered at the end of the handle. Hydrometers proved to be more accurate than thermometers in determining the proper density of the syrup.

In the early 1900s, these hand-cranked arm lifts moved the flat evaporator pan from the fire when the syrup had reached the sugar stage. The pan was then wheeled off to one side, where the syrup cooled and was stirred into sugar with wooden paddles. Ed Brown's Sugarhouse in Pittsburg still has a similar unit that operated from the ceiling.

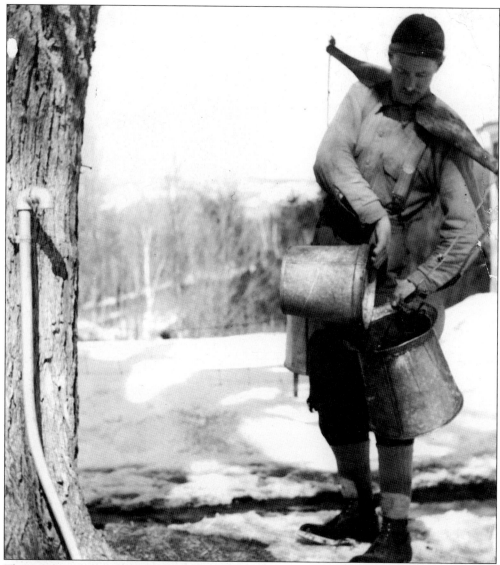

This unidentified man is collecting sap using a hand-carved yoke and gathering pails. What appears to be an early pipeline system is attached to the tree. This photograph was probably taken in the 1930s. Metal sap pipelines, smaller than this, were introduced in 1925 and turned out to be leaky, prone to freezing, and easily damaged by passing deer. Some sugar makers tried them, but they proved so unsatisfactory that most reverted back to gathering tanks drawn by dependable horses or oxen. For many more years, the idea of a tubing system continued to evolve in the minds of inventive maple producers.

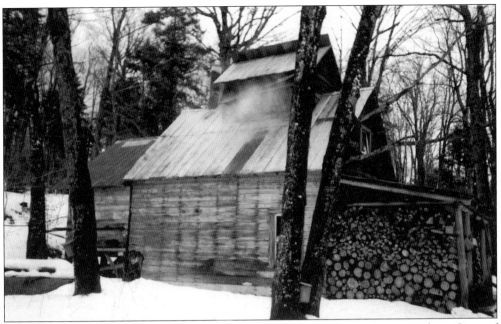

Replacing a building constructed in 1854, this sugarhouse belonging to Robert Gray of Pittsburg was built in 1945. Now in his late 70s, Robert helps his son Lindsey with the springtime harvest. They make between 60 and 100 gallons of syrup each year and sell much of it from Robert's farmhouse.

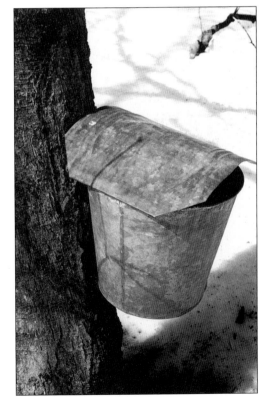

Metal sap buckets and covers were introduced in the late 1800s. Early sugar makers put up to 10 taps in a large tree, but modern beliefs dictate that no more than two taps be used to minimize the amount of damage to a tree. Below-freezing nights and daytime temperatures in the 40s are ideal for good sap runs.

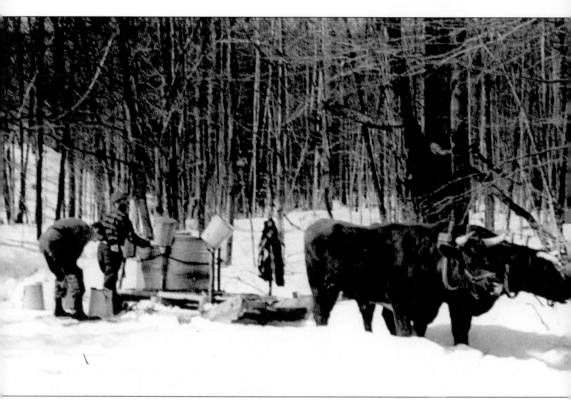

In this early-1900s photograph, two unidentified men are collecting sap. A thick blanket of early snow serves as an insulator for the tree roots, preventing deep frost penetration. Without a deep frost, the trees wake up with the first few consecutive days of above freezing weather. As the trees warm in the sun, the moving sap builds pressure within the tree, and the snow begins to melt away from the trunk. Before outdoor thermometers were common, old-time sugar makers knew it was time to tap when the snow began pulling away from the trees.

Clement Lyon, bureau of markets director, and Perley Fitts, commissioner of agriculture for New Hampshire (1947–1962), visit a sugarhouse in the late 1940s or early 1950s for an inspection. Lyon is carrying a cloth bag containing testing supplies. Since the 1860s, the New Hampshire Board of Agriculture (changed to the New Hampshire Department of Agriculture in 1918) has performed routine inspections of sugarhouses to bring agriculture from a primitive age to using updated methods.

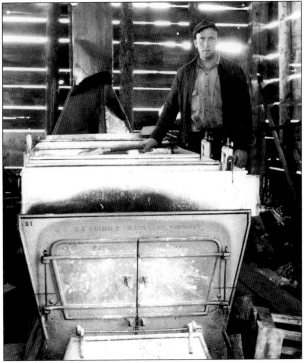

An unidentified sugar maker of the mid-1900s poses by his wood-fired evaporator manufactured by the G. H. Grimm Company. When founded in Hudson, Ohio, in 1888, this company sold Champion evaporators for about $100. Today, a similar evaporator sells for several thousand dollars. Pine slabs are often used in the evaporators, as they provide a quick, hot fire necessary to keep the sap boiling.

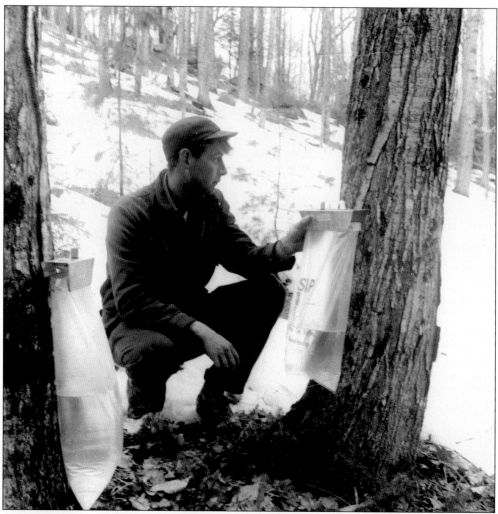

An unidentified man checks the level of sap collecting in a sap sack. These heavy-duty disposable plastic bags were first introduced in 1958 as a replacement for the bucket. They were a labor-saving device, eliminating the massive chore of washing hundreds or thousands of sap buckets at the end of the season. The space-saving bag also reduced the amount of debris in the sap. The holder could be used as a handle for carrying and also served as a cover. The sap sacks became quite popular by 1966, but demand decreased after marked improvements were made to plastic tubing. Sap sacks are still being used by some small producers.

Wearing a sap yoke, this c. 1940s maple producer lifts a felt filter used to strain sap or syrup. During World War II, the price of maple syrup was frozen at $3.39 per gallon, but there were no gallon containers available. All that were obtainable were round 46-ounce cans, which were made in abundance for military food. Maple production in New Hampshire dropped significantly during the war.

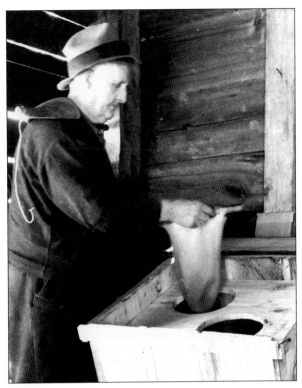

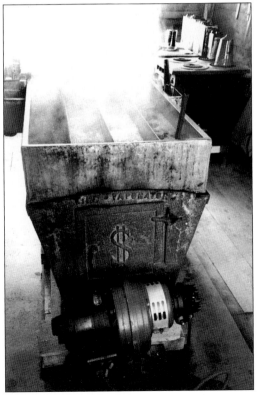

This King evaporator was made in the 1940s or 1950s and was converted from wood to oil before the late 1960s. It is still being used at Chase's Sugarhouse in Amherst. A unit like this often burns five gallons of oil to make one gallon of syrup. Newer and larger models are more efficient.

These visitors from Amesbury, Massachusetts, in the 1950s are dressed in their Sunday best to visit the Bolduc Farm sugarhouse in Gilford. They were treated to "leather aprons," or sugar on snow. Many sugarhouses throughout New Hampshire welcome visitors during the maple season, which generally runs from mid-February in the south to mid-April in the north.

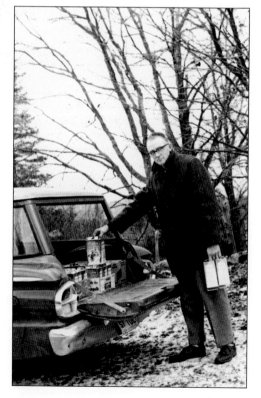

Ken Bascom of Acworth loads up his car with syrup, which he marketed to stores from Acworth to the Seacoast from the late 1950s through the 1970s. He also maintained a mail-order business. He served as a director and then as president of the National Maple Syrup Council, which was formed in 1959. Because of his many contributions to the maple industry, he was inducted into the Maple Hall of Fame in 1994.

In Sugar Hill, New Hampshire, large maples line the road near Charlie Stewart's Sugarhouse. Sugar makers used to plant trees along the roads because they were easily accessible for collecting the sap. Now, the liberal use of road salt eventually kills these trees. Sugar maples away from these roads can live for 300 to 400 years. Maple producers treasure their largest sugar maples, and most believe they yield the sweetest sap. Sap from a large healthy tree often contains 3 to 5 percent sugar. Sap with a high sugar content requires a shorter boiling time to reach the syrup stage because less water must be evaporated.

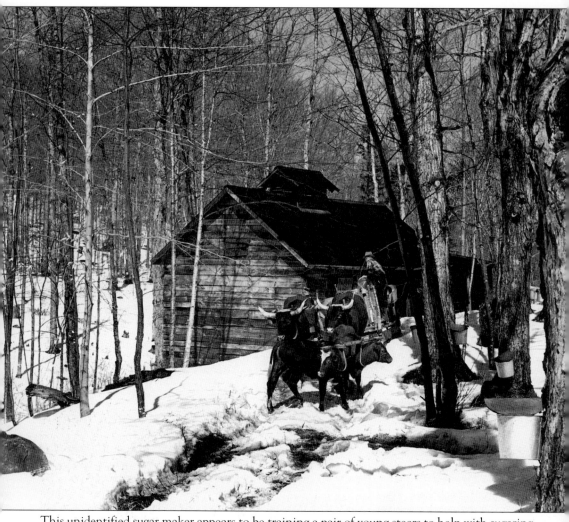

This unidentified sugar maker appears to be training a pair of young steers to help with sugaring while a yoke of oxen does the heavy work. Hundreds of sugarhouses or sugar shacks are tucked away in New Hampshire's woods and along the roadsides. It is believed that the state has over 1,000 commercial maple producers and backyard hobbyists, although the exact number is unknown. Many hobbyists have just a few taps and make only enough syrup for their own families. Years ago, the primary maple producers were farmers, but today, many are not. (Photograph by WENDAY.)

Judy and Bruce Bascom hang and cover buckets at the Bascom Farm in Acworth c. 1963. Bruce later took over his father's maple operation, which remains the largest in the state, with approximately 40,000 taps. The company also purchases sap and syrup from other producers, which is then processed and marketed to wholesalers worldwide. Bascom Maple Farms is the largest maple producer and equipment dealer in the state.

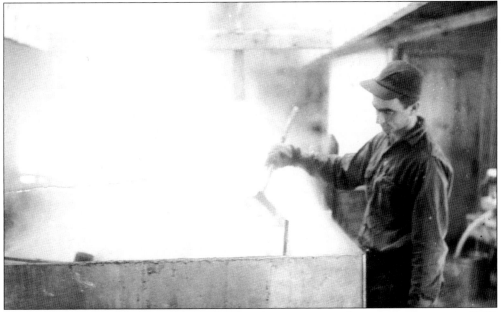

Richard Moore of Sunnyside Maples in Loudon skims impurities from the boiling sap in 1960. The Moore family served pancake breakfasts at their sugarhouse for many years. Although they no longer operate the restaurant, they still make maple products and sell them from their sugarhouse, through mail orders, and to stores.

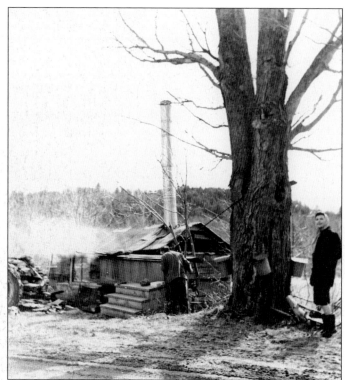

Photographed at Croall's Sugarhouse in Etna in 1964, Dean Croall checks the amount of sap in the holding tank while Janet Wheelock waits by the tree. At that time, metal buckets had been used for 100 years. Plastic tubing had just been introduced, but it was laid on the ground, and the sap often froze in the snow.

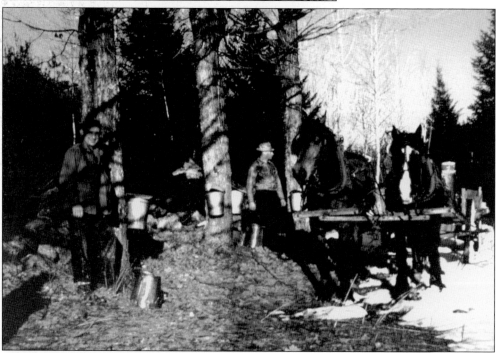

These unidentified workers wait for the horse-drawn wagon carrying the gathering tank to stop so they can empty their pails. Sleds were used more often than wagons to collect sap because if there was not a good snow cover, there was certainly plenty of mud, and wagons often became stuck.

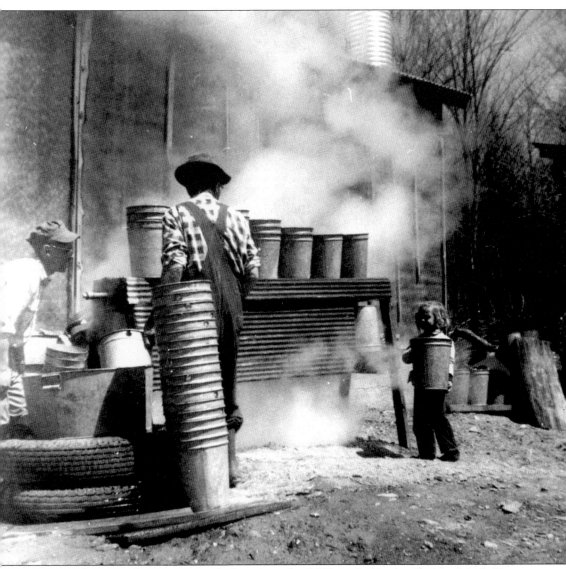

In 1959, three people at a time worked to clean the 5,700 sap buckets at Bascom Maple Farms at the end of the sugaring season. Youngsters and old-timers alike helped with the enormous task. A steam-powered bucket washer that Ken Bascom designed was used for several years. After the buckets were clean, they were turned upside-down to dry. Ken would stack up 20 dry ones at a time and shoulder them to the storage area. Today, Bascom Maple Farms maintains 40,000 and uses plastic tubing to carry the sap from the trees to the collection tanks.

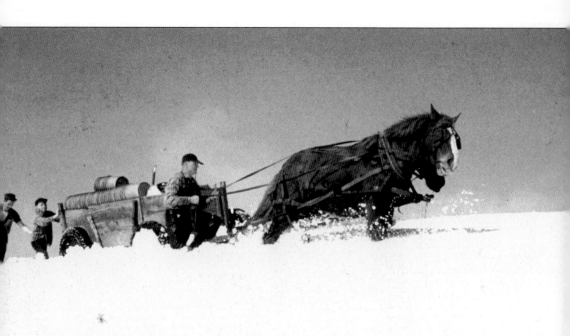

About 1963, Ken Bascom of Acworth drove this wagon with nearly 500 sap buckets out to tap. With luck, he could get two loads out in a day if the snow was not too deep. Here, helper Ruel Chase walks behind while young Bruce Bascom pushes the wagon. When Bascom's maple operation expanded, he used two teams of horses. The field they are crossing was later planted with Christmas trees and then with sugar maples. At this time, Ken Bascom served as a director of the National Maple Syrup Council, which had just begun publication of the *Maple Syrup Digest*, a magazine aimed at keeping producers throughout the maple belt informed.

Paul Messer began sugaring at Orford High School in his Future Farmers of America class. Because he lived next door to the school's sugarhouse, he was expected to help on weekends. His love of sugaring grew, and from then on he sugared at home. Here he stands at the right of his first sugarhouse in Orford. He rescued this building from destruction, moving it one mile on a trailer. Pictured with him are his children. From left to right are Paul Jr., Lowell, Christine, and a friend. At this time, Paul had about 150 buckets and boiled on a two- by four-foot hinged flat pan.

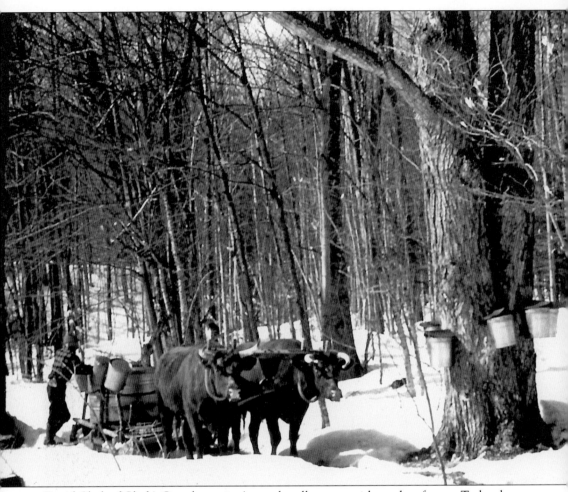

David Clark of Clark's Sugarhouse in Acworth collects sap with a yoke of oxen. Today, he uses plastic tubing to carry sap from over 3,700 taps more than two miles away, directly into the sugarhouse. The Clark family makes over 1,000 gallons of syrup and sells nearly all of it in the retail market. They also make maple cream, candy, and sugar. This family has been collecting and saving maple equipment for several generations and now has a substantial collection of artifacts. The Clark Farm was named a farm of distinction in 2001 for its well-kept property and modern maple operation.

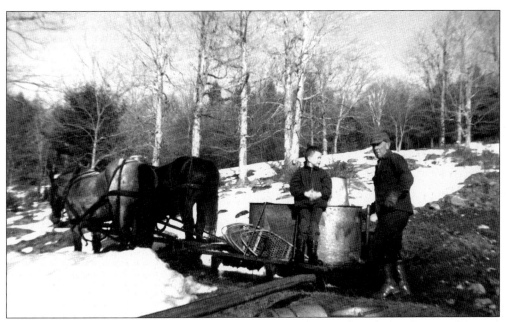

This photograph was taken c. 1962. Harley Bedell, a worker on the Johnson Farm in Monroe, talks with young Harold Johnson while preparing to empty the gathering tank. Sap was commonly collected at the highest elevations first so the horses could pull the heavy load downhill.

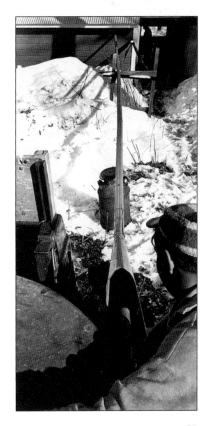

This picture, taken in the 1960s, shows an unidentified man unloading sap from the gathering tank at Sunnyside Maples sugarhouse in Loudon. The metal piping is supported midway by a milk can. Gravity is still the preferred conveyor of maple sap.

New Hampshire sugar makers are sometimes pranksters. Each year, Gordon Gowen of Acworth taps a utility pole just to arouse curiosity. Visitors often ask how much sap he gets from the pole and if there is any creosote in it.

In 1961, Alvin Clark of Acworth is shown filling rubber molds to make maple candy to sell at Eastern States Exposition in Springfield, Massachusetts. When making maple candy, light amber or medium amber syrup is preferred. New Hampshire maple producers sell syrup, sugar, candy, maple cream, mustard, pepper, barbecue sauce, and many other products containing maple syrup.

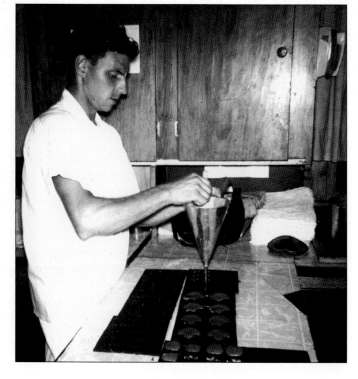

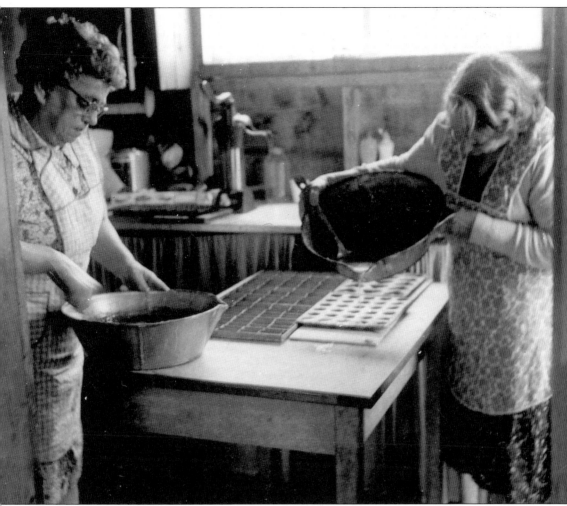

In this picture, Richard Moore's grandmother, Inez Moore (left) and his mother, Isadore, make maple candy in Richard's Sunnyside Maples sugarhouse in Loudon c. 1962. The Moore family has been selling maple products from this sugarhouse since 1952. Richard and his son now have 2,500 taps on tubing and make about 500 gallons of syrup. Richard's wife, Elaine, and their daughter Laura Howell make maple sugar, candy, and a variety of other maple products, which they supply to 200 stores and ship all over the world. Because maple products are made almost exclusively in the northeastern United States and southeastern Canada, they are seldom seen on store shelves far beyond the maple belt.

Boiling down the sap is time-consuming because approximately 39 gallons of water must be evaporated to make one gallon of syrup. In this 1960s photograph, filters hang over the side of the evaporator pan. The maple sap is boiled down in the evaporator over a roaring hot fire. As it boils, it often foams up over the top of the pans. When this happens, one drop of fat or defoamer instantly tames the rising foam.

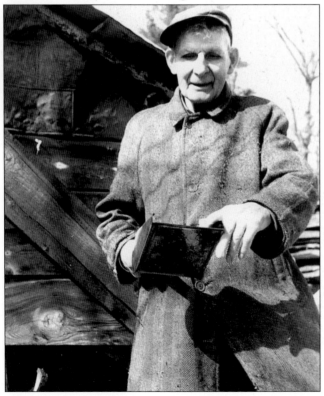

In this 1964 photograph, David Croall prepares to taste syrup in the scoop at Croall's Sugarhouse in Etna. Maple production continued to decrease throughout the 1960s. Because of the shortage, syrup prices rose from $6 per gallon in 1960 to $9 per gallon by 1970.

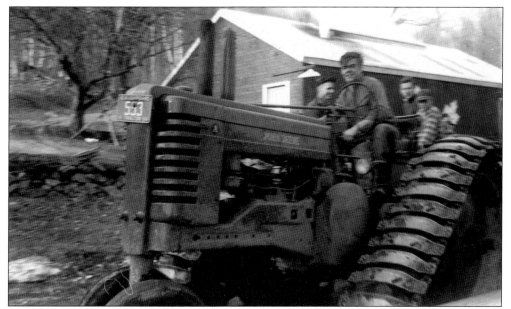

With unidentified men behind him, John Putnam poses on neighbor Ken Bascom's tractor in Acworth in 1964. Replacing the horses with a tractor allowed for heavier loads to be hauled greater distances. The tractor increased the speed of collecting sap from Bascom's expanding operation. This half-track tractor was especially good for traveling through snow and mud. If the snow was too deep, a bulldozer was used to break open the road.

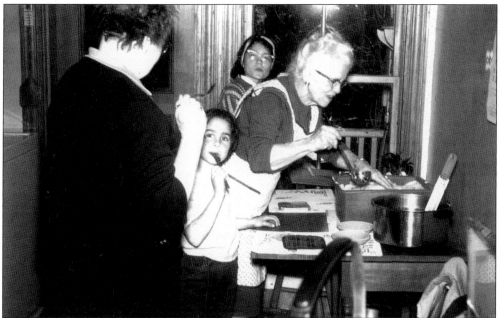

Everyone flocks to the kitchen at Tamarack Farm in Acworth when sugar on snow is served. This taffy-like treat is highly sought after during the sugaring season. Syrup is cooked to about 233 degrees and is then drizzled over clean snow or crushed ice. Here, an unidentified woman on the left joins Karen and Gail Gowen in sampling the treat while Abbie Gowen prepares more. Several generations often help out during the sugaring season.

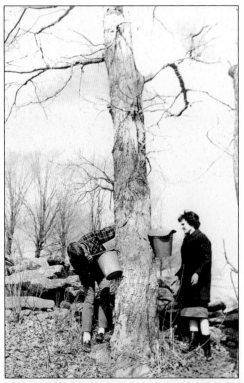

In 1964, these two unidentified visitors at Croall's sugarhouse in Etna look to see how fast the sap is dripping. When the maples thaw after a night of freezing, the sap in the tree moves and builds pressure within the tree. When that pressure reaches a certain point, sap will drip from any fresh wound in the tree. Squirrels take advantage of this, nipping a spot on the underside of a branch and drinking the slightly sweet liquid that escapes.

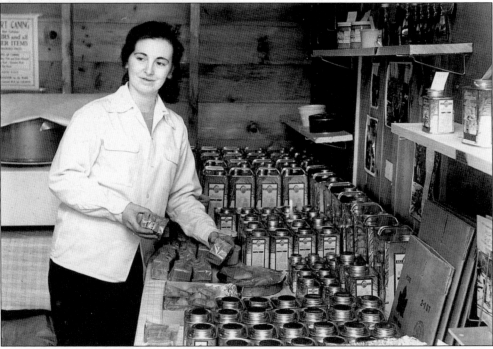

Louise Moore stocks the display table at Sunnyside Maples in Loudon. For five generations, the Moore family has worked together making and selling their maple products. They also sell maple-sugaring supplies and equipment to other producers and backyard hobbyists.

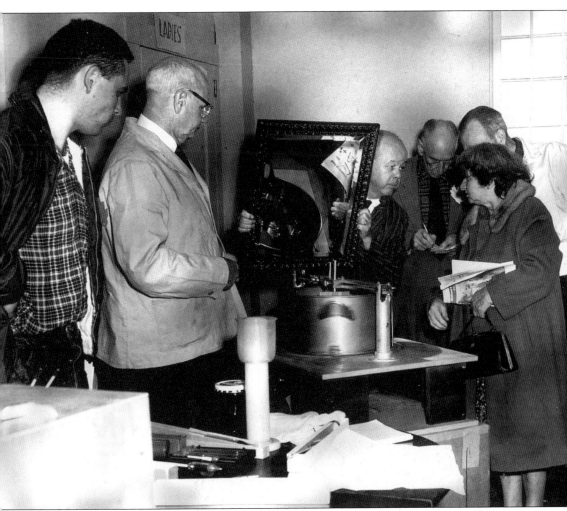

Each year the New Hampshire Maple Producers Association hosts free educational sessions around the state for anyone interested in making maple syrup. These sessions are an excellent opportunity to learn the latest techniques in the craft. Other classes are conducted at the association's annual and summer meetings. Maple supply and equipment dealers display their wares at each of the annual meetings. Fred Bean, former farm editor for the *Union Leader*, snapped this picture of a salesman demonstrating a maple cream machine to interested maple producers. Maple cream is made by heating pure maple syrup to about 235 degrees, cooling it quickly to less than 70 degrees, and then stirring until the syrup takes on a creamy consistency. It is delicious spread over toast and English muffins but must be kept refrigerated.

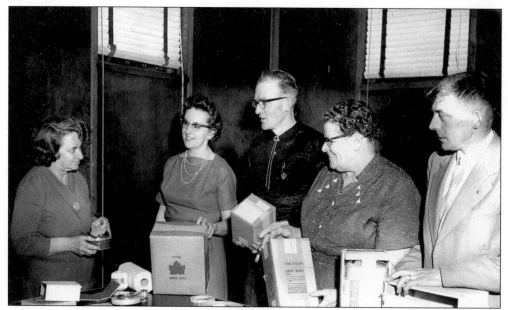

Here panelists at one of the association's educational sessions discuss packaging and shipping practices. Panelists are, from left to right, Mrs. Lauris Moore of Loudon, Ruth and Kenneth Bascom of Acworth, Frances Crane of Washington, and Benjamin Porter of Langdon. Fred Bean, former field editor for the *Union Leader*, took this photograph in the 1950s or 1960s.

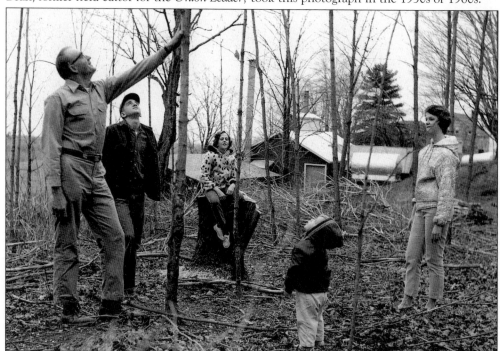

Ken Bascom poses with his children. From left to right are Ken, Bruce, Nancy, Brad, and Judy. They are studying a young stand of sugar maples in Acworth in 1966. It takes approximately 40 years for a tree to reach 12 inches in diameter, the acceptable size for one tap. These trees have now reached that size and are being tapped.

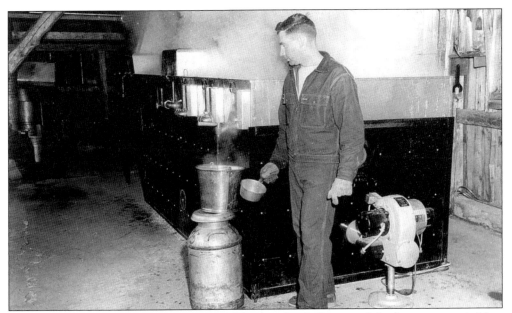

Charlie Stewart of Sugar Hill owned one of the first G. H. Grimm oil-fired evaporators in New Hampshire in 1965. This photograph, taken by Charles Trask of Trask's Studio of Franconia, shows the 5- by 14-foot unit in action. Stewart has been sugaring on the family farm since he was old enough to help his father. At one time, he had 15,000 taps, but now with the help of his daughter and a nephew, he maintains approximately 2,000 taps.

In 1982, modern plastic tubing fed sap into this 1920s-era storage tank at Bolduc's maple orchard in Gilford. Charles Bolduc, father of the present owners, recorded information about each maple season on this tank. Over the years, many others have added their wise and not-so-wise sayings on the side of the tank. Cheryl DiLorenzo moves on after reading some of the inscriptions.

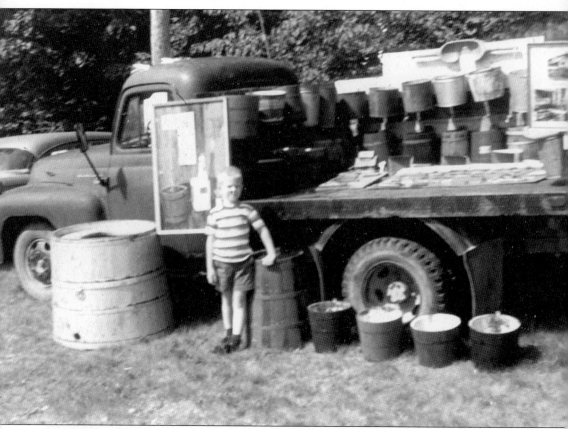

In 1967, David Clark of Acworth poses next to his father's display of old wooden sap buckets and other equipment at the Acworth Maple Festival. From the late 1950s through the 1970s, New Hampshire's maple production declined. Because of many recent time- and energy-saving inventions, maple output has rebounded since the 1980s and is now back to the 1930 level. Sugar makers no longer need to hire as much help, and new equipment makes it less time-consuming to produce large amounts of syrup. The state's maple production is expected to continue increasing gradually over the next decade.

Ken Bascom with his son Brad, is drawing off syrup from the steam-fired evaporator. Bascom's steam boiler was one of the first of its kind in New Hampshire, where steam-filled pipes ran through the evaporator pan to boil the sap. Bascom designed his own evaporator pan, used the first ultraviolet sterilizer in New Hampshire, and owned the first reverse-osmosis machine in the state. Bascom Maple Farms still uses a steam-fired evaporator.

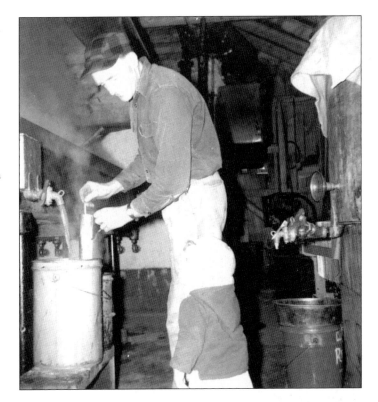

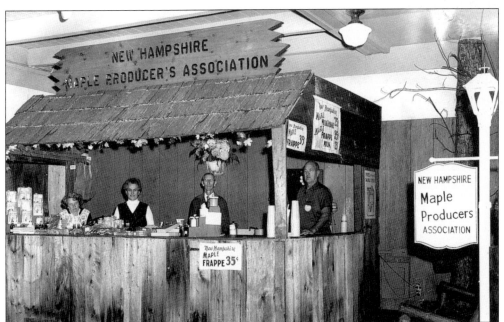

In 1969, staff members of the New Hampshire maple booth at the Eastern States Exposition in West Springfield, Massachusetts, pose for a photograph. From left to right are Lauris Moore, Mrs. Alfred Despres, Harry Gowen, and Kirk Heath. Members of the New Hampshire Maple Producers Association promote their products at this and several fairs around New Hampshire.

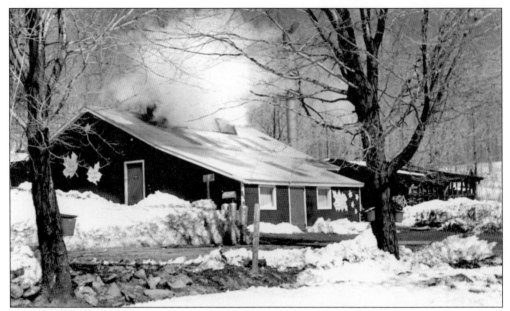

By 1984, Ken Bascom was making over 12,000 gallons of syrup in this Acworth sugarhouse, boiling day and night. On rare occasions at night, Ken would step outside the sugarhouse and discover that the steam billowing from the roof froze and fell as snow just around the building. In 1966, Bascom's burned 107 cords of wood during the sugaring season. The woodshed next to the sugarhouse held 40 cords.

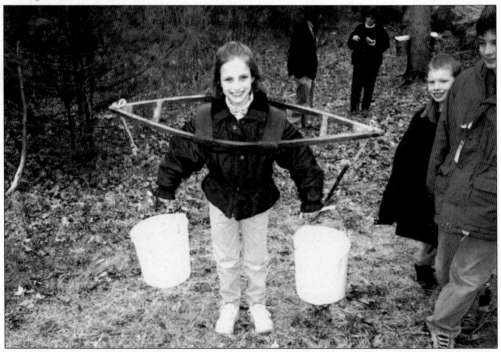

This unidentified child visiting Maple Lane Products sugarhouse in Concord models a sap yoke. These yokes were made in many different styles and were used for over 200 years. They were designed to reduce the weight on the arms, lowering the risk of injury during a day of carrying sap.

Three
TECHNOLOGICAL LEAPS
1971–2004

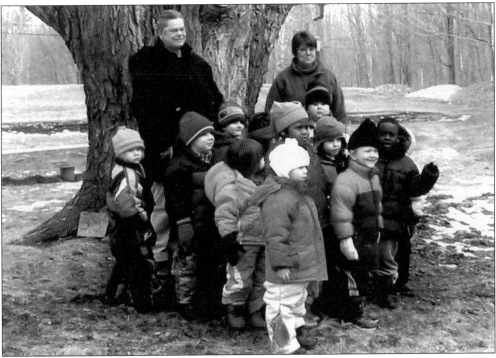

A preschool class visiting the Bolduc Farm Sugarhouse in Gilford poses near an enormous maple that stood before George Washington became president and is still being tapped today. The farm had many maples of the same age, but most were taken when a nearby highway was built, and others succumbed from the road salt used on that highway.

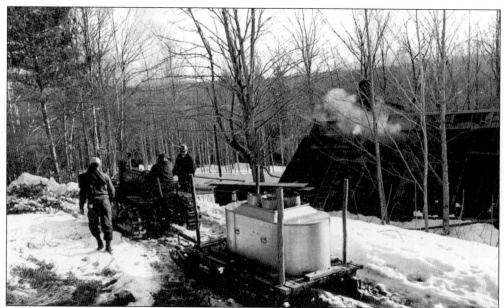

In this April 1971 photograph, a tractor hauls a sap-filled gathering tank to Clarence Pulsifer's Sugarhouse in Campton. After the tank is emptied at the sugarhouse, these unidentified workers will return to the maple orchard to collect more sap. Sugar makers who had thousands of taps kept one or more crews working all day emptying buckets. Most gathering tanks had interior baffles to prevent the sap from sloshing around.

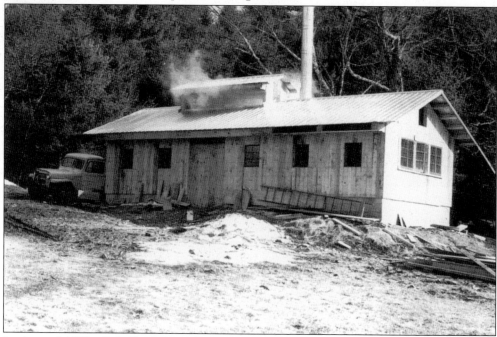

In the mid-1970s, Bob Sherburne of Franconia had a brand-new sugarhouse that he named Pinestead Sugarhouse. The cupola, or roof vent, has doors that can be closed by the pull of a rope when the evaporator is not in use. This sugarhouse also has plenty of windows. In the early days, sugarhouses had few windows, probably because of the added expense.

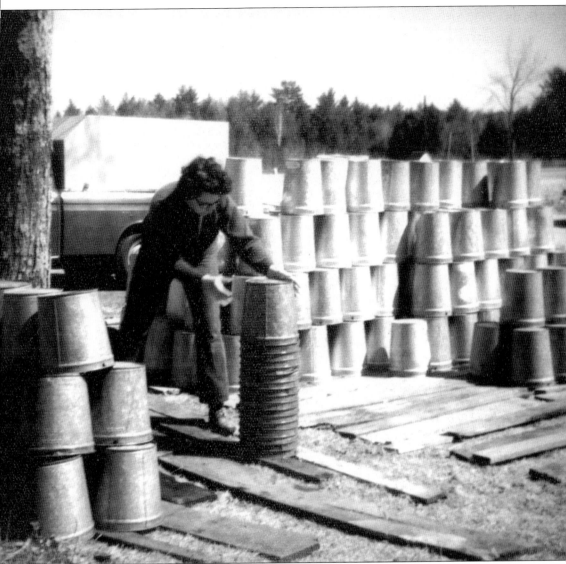

This unidentified worker at Sunnyside Maples in Loudon helps with washing some of the 3,500 buckets the Moore family used for many years. Richard Moore operated a motorized scrubber to clean the buckets, while other members of the family rinsed and stacked them to dry. In 1970, New Hampshire's maple production was 56,400 gallons, which sold for approximately $9 per gallon. In 1974, Canadian production of maple syrup increased dramatically, causing the price to plummet. As a result, the International Maple Syrup Institute was organized in an effort to improve marketing of pure maple syrup.

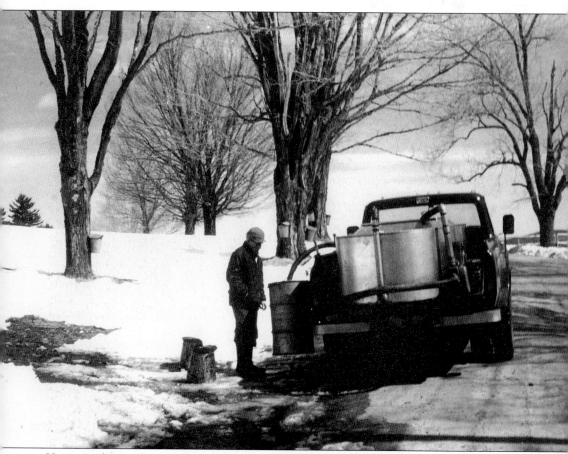

Horses and oxen eventually yielded to truck and tractor power. To save labor, most sugar makers use electric or gasoline-fired pumps to transfer the sap, as James Stewart of Sugar Hill is doing in this 1976 photograph. A single tap hole will yield about 10 gallons of sap per spring, which will condense to about a quart of syrup. In order to prevent spoilage, the sap should be collected daily, kept cold, and boiled down as quickly as possible. With too little profit to hire outside help, most sugar makers depend on family members to help with the four- to six-week maple harvest.

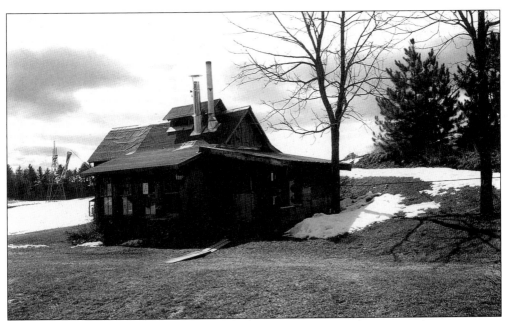

As a maple operation grows, so must the sugarhouse. Most of these structures have numerous additions like the one seen in this picture of My Old Farm Sugarhouse in Winchester. Originally built in 1814 as a corn crib, it was later converted to a sugarhouse and then enlarged over the years. The Harold Bigelow family now makes 30 to 40 gallons of syrup in this building.

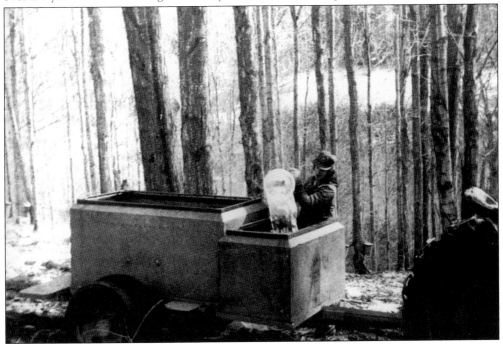

An unidentified helper at Clark's maple orchard in Acworth pours sap into a gathering tank in 1978. The energy crisis of the 1970s threatened the maple industry. As a result, many energy-saving devices were invented, helping maple producers to make larger quantities of syrup with less manpower.

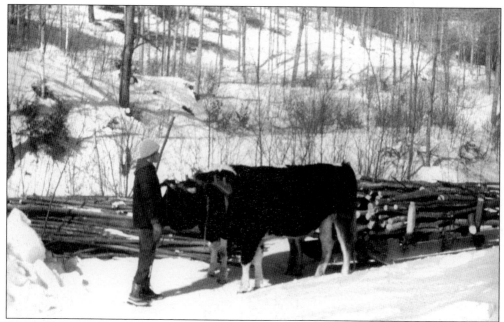

In 1979, young David Clark of Acworth used his oxen to haul firewood to the family sugarhouse. Maple producers who burn wood usually fill their woodsheds during the fall and winter. Today, David operates the sugarhouse utilizing many new innovations, but he is still firing the evaporator with wood.

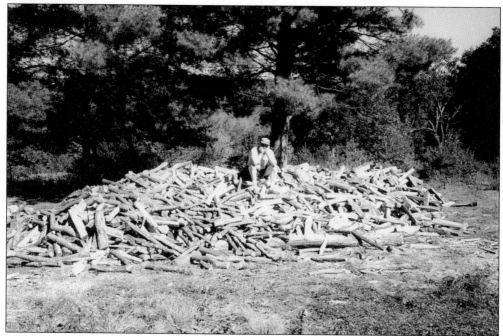

Cutting and splitting enough firewood to make maple syrup can be an overwhelming task. Here, an exhausted Dean Wilber of Concord rests atop the four cords of wood he will use in his sugarhouse. The firewood still must be hauled to the sugarhouse and stacked in the woodshed so it will be dry and easily accessible during the maple season.

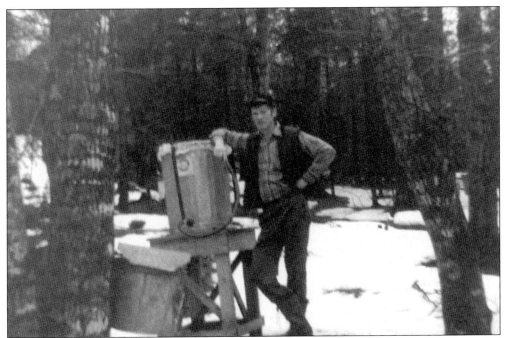

In 1979, Lindsey Gray rests at this dumping station near his sugarhouse in Clarksville. Dumping stations proved to be valuable timesavers when the family hung buckets on their trees. Sap collected from the buckets was poured into this barrel and piped down to the sugarhouse.

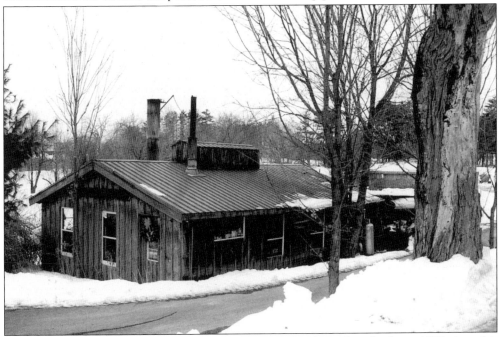

The house and barn at the Peterson Farm in Londonderry date back to 1775, but this sugarhouse was constructed in 1981. That next spring, Hank Peterson made about 125 gallons of syrup. Today, he produces about 150 gallons and is the only commercial maple operation in that town.

Loaded down with a backpack and his hands full, David Holmes of Fitzwilliam heads out to tap in 1986. Tapping trees and making maple syrup is an undertaking an estimated 500 to 700 commercial maple producers and 500 to 700 backyard hobbyists in New Hampshire look forward to every year.

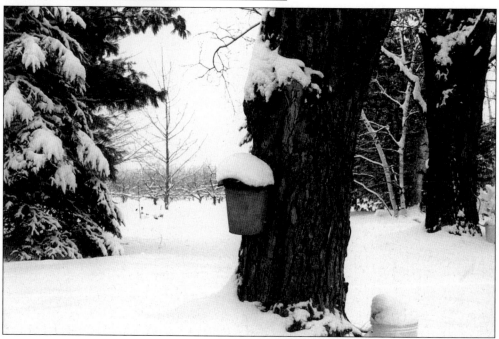

Snowstorms are common during the sugaring season and do not harm the sap. The cold weather that brings the snow merely halts the flow of sap for a few days, giving the maple producer a much needed break. As soon as the weather warms, the sap flows once again, often resulting in a lighter grade of syrup than before the storm.

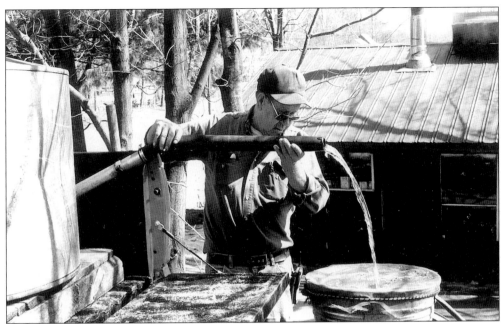

Hank Peterson of Peterson Sugarhouse in Londonderry unloads sap from his gathering tank and filters it before it goes into the evaporator. As the sap boils, sugar sand, or niter, accumulates. When the syrup is drawn from the evaporator, it is well filtered to remove all impurities, leaving a clear syrup.

A myriad of clean felt and cloth filters hang to dry at Holmestead Sugarhouse in Fitzwilliam in 1984. Adequate filtering is the key to producing a clear syrup. Filters and other maple equipment should be washed with only hot water. Using soap might leave a residue that could taint the syrup.

In this 1982 photograph, David Holmes of Fitzwilliam boils a pot full of sap in his first sugarhouse while his son Jon looks on. Many maple producers start out with a crude shelter like this and boil in kettles pilfered from the family kitchen. As their love of sugar making grows, so does the sugarhouse and amount of equipment.

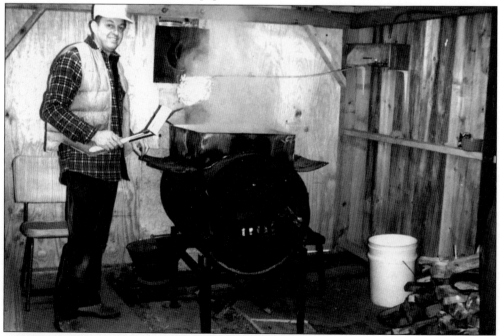

In 1989, Donald Lassonde used this homemade barrel evaporator, which worked well for the 40 taps he had. To preheat his sap, it flowed through copper tubing wrapped around the stove pipe and covered with foil before entering the pan. If much cold sap is added to the pan, the boiling will cease.

The Snow Farm Sugarhouse in Wolfeboro was built in 1982 and houses a two- by four-foot wood-fired evaporator. Owners Jim and Liz Bean make about 35 gallons of syrup from the 100 taps they have on buckets. They mount their collection barrel on a tractor, which they drive through the maple orchard.

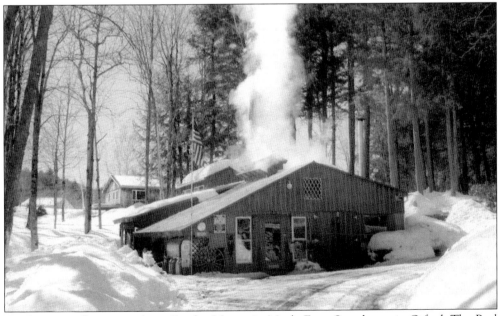

An American flag waves above Sunday Mountain Maple Farm Sugarhouse in Orford. The Paul Messer family has had a sugaring operation since 1957, which has grown from 100 buckets to 3,000 taps. They sell their maple products year-round from their sugarhouse and to mail-order customers.

Gordon Gowen of Acworth found it difficult to collect sap from these buckets during a spring flood in the 1980s. For many years, he was active in maple organizations, even serving as president of the North American Maple Syrup Council. Because of his many contributions to the maple industry, he was inducted into the Maple Hall of Fame in 1987.

An ice jam on the flooded Cold River in Acworth in the 1980s carried some of Gordon Gowen's buckets many miles away to the Connecticut River. From 1984 to 1987, four poor years of maple harvesting resulted in low supplies and high prices. Syrup was so scarce that producers could charge whatever they wanted.

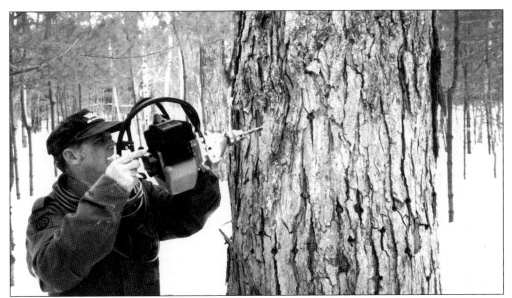

Armand Bolduc of Gilford uses a gas tapper to tap his trees. Sometimes it is necessary to tap a tree higher up on the trunk to allow for gravity flow. The first commercial power tapping machine was marketed in 1946. It was larger and heavier than the one shown here. As improvements came about, they became smaller and more lightweight. Today, most maple producers use small battery-operated drills.

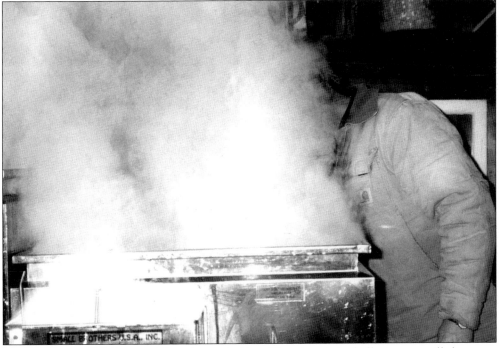

David Holmes of Holmestead Sugarhouse in Fitzwilliam has waited all year to smell the sweet vapor of boiling sap. The unique smell of maple carries through the air, and the sight of steam billowing from a sugarhouse draws friends, neighbors, and strangers alike into the warm, friendly atmosphere of the sugarhouse.

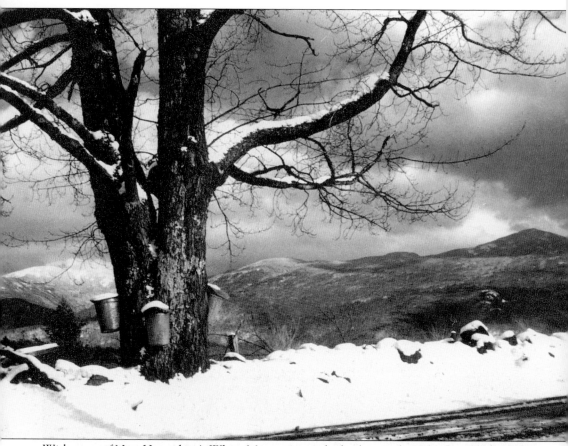

With some of New Hampshire's White Mountains in the background, sap buckets hang on this large maple in the town of Sugar Hill. In summer, maple trees provide a shady canopy. In autumn, the brilliant red, orange, and yellow leaves of the sugar maples paint these hills and mountains with breathtaking hues. This three-week autumn phenomenon is plainly visible from space—the flood of gold spreading south at a rate of 40 miles a day from Canada through the Carolinas. New Hampshire's vibrant fall colors draw tourists from around the world.

This large maple in Amherst is probably well over 100 years old. Scientists are concerned about the effect acid rain and global warming will have on sugar maples in the years to come. These cold-loving trees flourish in the Northeast. It is believed that when weakened by changing soil conditions caused by acid rain, the trees will be less able to ward off attacks from insects and blight.

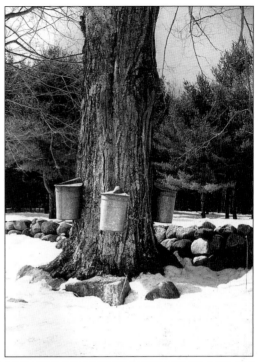

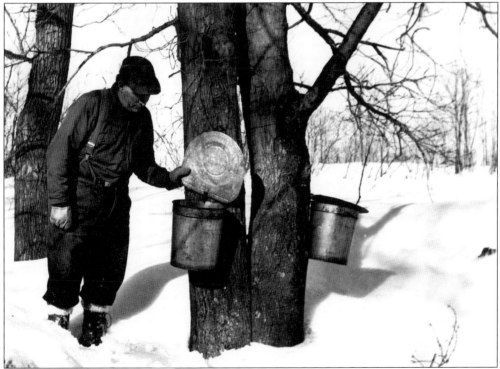

Howard Reed of Etna checks to see if the sap is running. Taps on the sunny side of the tree will run before those in the shade, and often in larger quantities. Trees are affected by the wind chill, so sap will not usually run on a cool, windy day.

This photograph was taken *c*. 1987. Here, Tim Gowen of Tamarack Farm in Acworth hauls sap with an unidentified child riding with his son Blake and wife, Clare. The Gowen family has been making maple syrup for six generations, every year since 1877. The first building on the Gowen property was a house built in 1820, which was later converted to a sugarhouse and used through the 1990s. To communicate between this sugarhouse and their home, the Gowens used an old-fashioned crank telephone. Back in the early 1900s, the county schoolhouse was situated on the Gowen property, and the teacher boarded at the farm. Gordon Gowen attended first grade there.

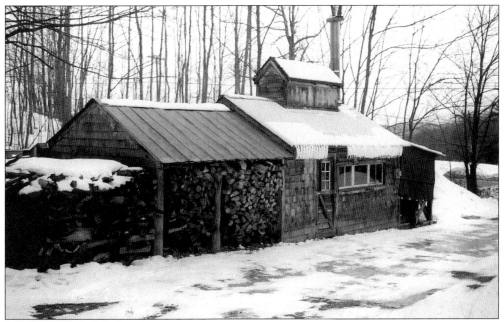

This Bolduc Farm Sugarhouse was built in 1989 and is well stocked with firewood for the pending season. Pine slabs or chunks are the preferred fuel for wood-fired evaporators because pine creates the quick, hot fire needed to evaporate the water from the sap. The Bolduc Farm maple orchard, or sugar bush, is the oldest continually run maple operation in the United States.

It is humid inside the Holmestead Sugarhouse in Fitzwilliam with two evaporators operating. The sweet-smelling steam beckons visitors while David Holmes boils down his sap twice as fast. When the boiling sap nears the syrup stage, it must be watched closely so that it is drawn off before it burns.

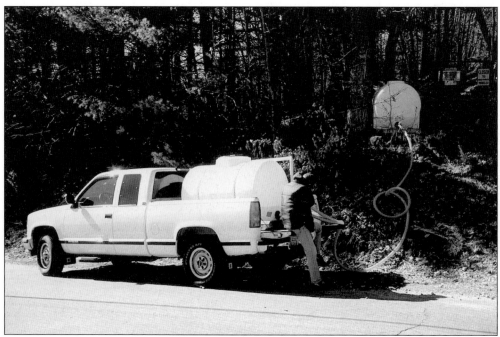

Dean Wilber of Concord collects sap from a collection tank at the edge of his maple orchard in 1996. The use of plastic tubing and motorized pumps make it possible for one person to do the work of many, collecting hundreds of gallons of sap each day.

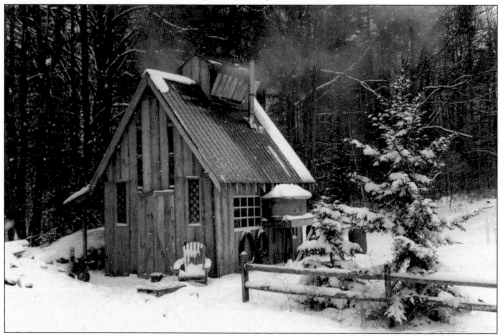

Charles Levesque's Old Pound Road Sugarhouse in Antrim sits at the edge of a clearing. He has been making maple syrup for 10 years and now makes about 54 gallons from 270 taps. There are many small-scale producers in the state who contribute to New Hampshire's overall production of nearly 90,000 gallons.

An old-time way of testing to see if syrup is done is to dip a scoop into the boiling syrup and then let it drip back into the pan. If the last of the syrup falls in a sheet, called sheeting or aproning, the syrup is considered the proper density. Testing with a hydrometer is a more accurate modern method.

Part of sugaring at Bill and Candy Mellett's sugarhouse in Woodstock is passing the tradition on to future generations. In this 1994 photograph, the Melletts' grandchildren Elizabeth and Zachary Mellett find suitable seating in the sugarhouse doorway to enjoy a break blowing bubbles.

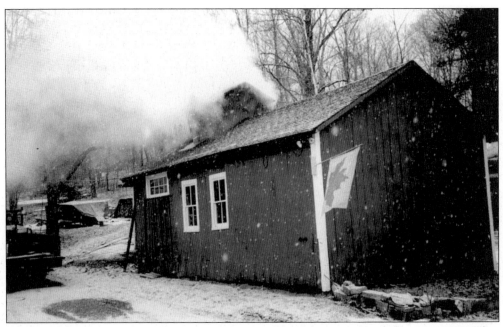

As snow falls, steam billows from the Holmestead Sugarhouse in Fitzwilliam in 1998. That winter, a severe ice storm hit the Granite State, breaking off limbs and tops of trees and devastating the maple industry. Some maple orchards were hard hit, while other escaped with little permanent injury. A surprising number of badly damaged trees are recovering.

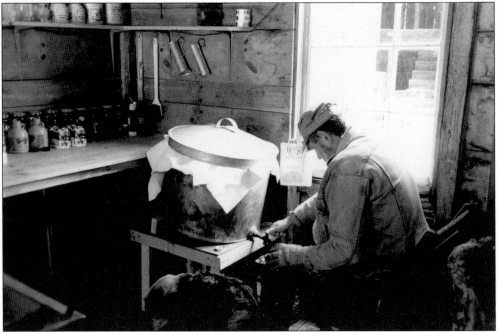

With his dog Sadie as company, Howard Chase bottles fresh syrup in his Amherst sugarhouse in 1996. In the early 1970s, the Chase family converted their 1775 shed into a sugarhouse and began making maple syrup. Today they are among hundreds of small-scale maple producers in the state.

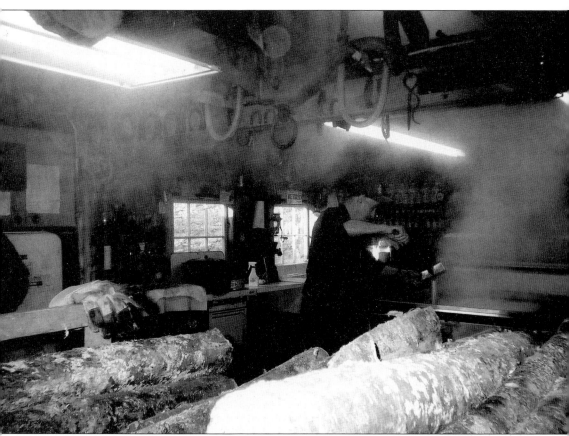

Firewood is stacked close by the evaporator for easy access, while antique maple and farming equipment adorn the ceiling and walls of Pease's Scenic Valley Sugarhouse in Orford. It was long believed that burning wood gives syrup its great flavor. Now, with the increased use of oil fueling evaporators, those maple producers find their syrup tastes just as good. Like most New Hampshire natives, Gerald Pease and many sugar makers appreciate antiques and readily collect them and other items that will someday become antique. Sugarhouses are often decorated with old maple supplies and equipment.

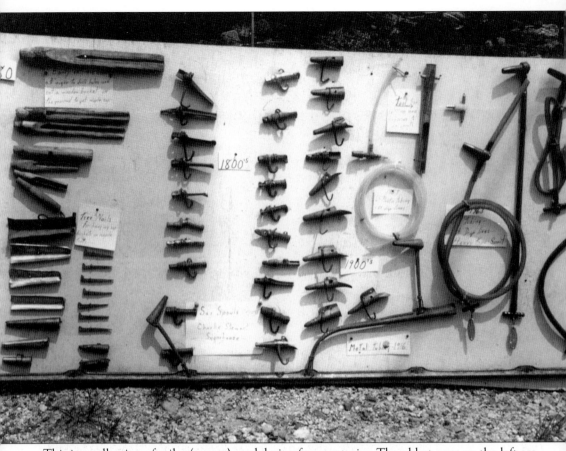

This is a collection of spiles (spouts) used during four centuries. The oldest ones on the left are long, wooden spiles used in the 1700s; then came metal spouts with tree nails for hanging buckets in the 1800s. Metal spiles with hooks were used throughout the 1900s, and metal tubing was used briefly from 1916. Plastic tubing was introduced in the late 1900s and continues to be widely used. Native Americans chopped slash marks into the trunks and inserted bark or reeds to funnel the sap into a wooden trough below. Early settlers began drilling holes and inserting hand-whittled spouts. Spiles became smaller as years passed and producers learned that large holes are unnecessary and take a long while to heal. Recently introduced, but not shown here, are the tiny micro spouts, which require a $9/64$-inch hole.

Snowshoes hang alongside fair ribbons in Chase's Sugarhouse in Amherst. Snowshoes must often be worn when the sugar makers tap their trees in mid- to late February. Warm days of the maple season soon reduce the deep snow to puddles. Many maple producers enter their syrup into competitions at local fairs.

In the 1700s and early 1800s, syrup was filtered through wool blankets. Today, felt or paper filters are preferred to remove sugar sand, or niter, which forms as sap is boiled. Dean Wilber of Maple Lane Products in Concord washes his felt filters in an old wringer washing machine.

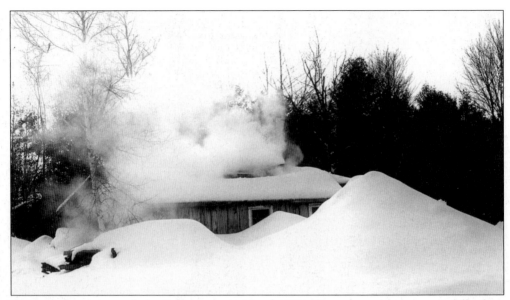

This sugarhouse is nearly buried in snow in March 2001. Deep snow creates many difficulties for the maple producer who must do his work in the woods wearing snowshoes. If taps are drilled about waist height, as is usually done, when the snow melts the producer may need a ladder to remove his taps. Heavy snow also weighs down the plastic tubing or buries it completely. Some snowfall is common during the sugaring season, and cold weather usually gives the maple producer a welcomed break.

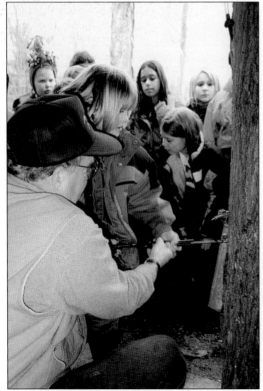

Dean Wilber of Concord shows a group of schoolchildren how to drill a hole in a tree for tapping. Many maple producers welcome the opportunity to teach youngsters about maple sugaring. During the maple season, busloads of children enjoy tours of sugarhouses and samples of fresh maple syrup or sugar on snow.

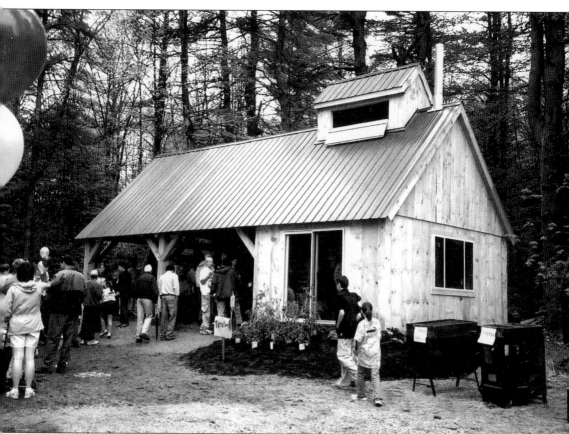

Several schools in New Hampshire operate sugarhouses so their students can learn the ancient art of maple sugaring. In 2001, the Moharimet Elementary School in Madbury held a dedication ceremony for their newly constructed sugarhouse. This was built in cooperation with the University of New Hampshire Forestry Department, and the lumber was cut from school property. Several maple producers donated sap buckets for the schoolchildren to use. Old-style evaporators are displayed on the right. Various schools around the state have offered courses on maple sugaring at some point for over 40 years.

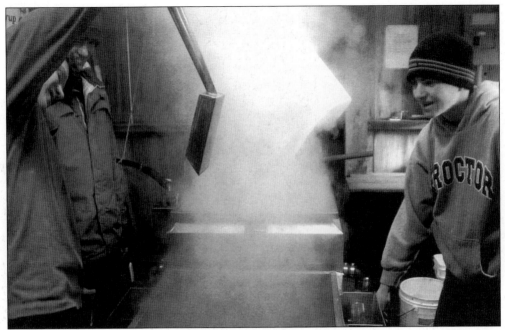

Students at Proctor Academy in Andover check the aproning, or sheeting, of their syrup. Proctor Academy, a private residential school for high school students, has operated a sugarhouse for several years, and the syrup produced by the students is given to them to take home. Besides fulfilling the required curriculum, Proctor offers additional courses such as woodland management and agriculture.

A large group of students visiting from France wanted to learn about maple sugaring while in New Hampshire. Paul Messer of Orford drove through wood trails to transport them to and from his sugarhouse and explained this springtime harvest. Except for a small amount made in Russia, maple syrup is made only in 14 northeastern states and four provinces of Canada.

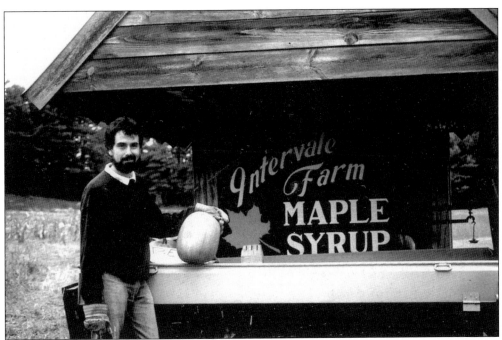

Patrick Connor poses next to one of his sugarhouse signs. His Intervale Farm Pancake House in Henniker is open for breakfast year-round. Glass doors separating the restaurant from the sugarhouse allow diners to watch the boiling process while they enjoy pancakes with his maple syrup.

Here at Proctor Academy in Andover, an unidentified student pours sap into the gathering barrel. Trees are sensitive to the wind chill, so during the maple season, if the weather is too cold or windy, the sap will not run. If nighttime temperatures remain above freezing, the sap will not usually run; however, on rare occasions if the pressure within the tree is great, the sap will run day and night for up to three or four days.

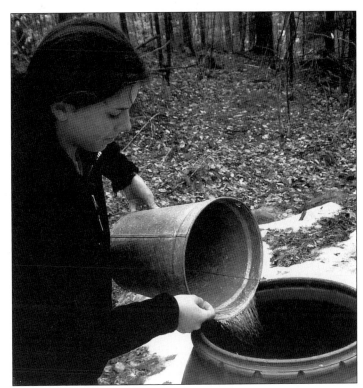

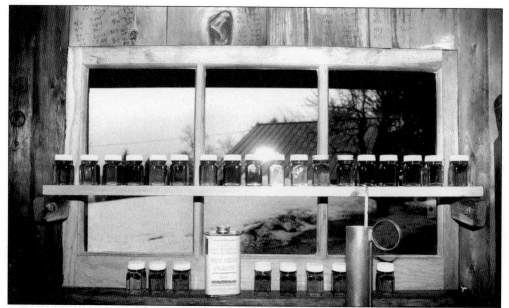

Many producers display a sample of each batch of syrup made during the season. Here at Maple Lane Products in Concord, the top shelf samples are from 2003, and the bottom row is from 2002. The color of maple syrup generally darkens as the season progresses but will sometimes lighten after a snowstorm or a cold spell. The lighter syrup has a delicate maple flavor, while the dark syrup has a stronger, more robust flavor.

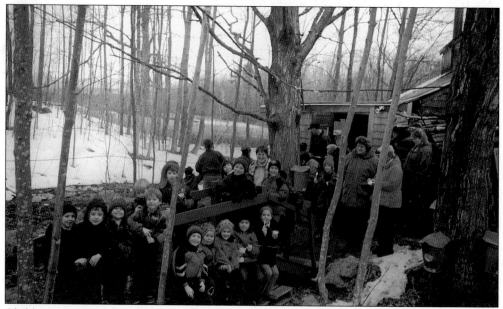

Children visiting the Bolduc Farm Sugarhouse in Gilford pose on a bridge spanning a brook. The Bolduc family enjoys educating classes of children and others about maple sugaring. This farm, built in 1779, is situated on over 300 acres and has been owned by the Bolduc family for several generations.

Roy Hutchinson operated this sugarhouse in Canterbury for over 40 years. This picture, taken by Normand Allard, shows the many additions built over that period. A new sugarhouse has replaced this one on the Hutchinson property, and Roy's son Brian and his family now operate the maple business.

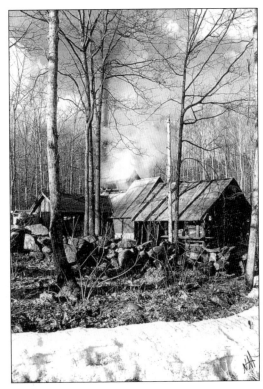

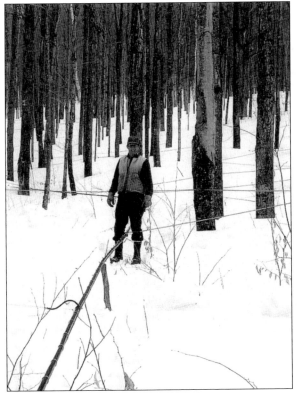

Plastic tubing zigzags down the hill as it stretches from one maple tree to the next. Here, Paul Messer of Orford checks for leaks. The introduction and improvements made to plastic tubing saves countless hours of labor collecting the sap. Moose, bear, deer, coyotes, and squirrels sometimes damage the tubing, so occasional inspections are necessary.

Paige Wilber waits patiently to catch a drop of sap at her grandparents' Maple Lane Products sugarhouse in Concord. Her cousin Riley Wilber watches. Riley's mother, Jennifer Wilber, caught the moment on film. Sap is the food of the maple tree consisting of water, sugar, and a small amount of calcium, iron, potassium, and sodium.

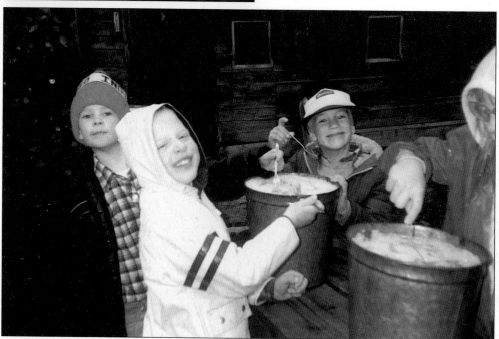

Gray's Sugarhouse in Clarksville provided these children with a treat of sugar on snow. The children are, from left to right, Christopher Gray, Matthew McKeage, Seth Gray, and Sarah Gray. Because of its unique flavor, maple syrup and sugar are important ingredients in hundreds of time-tested New Hampshire recipes.

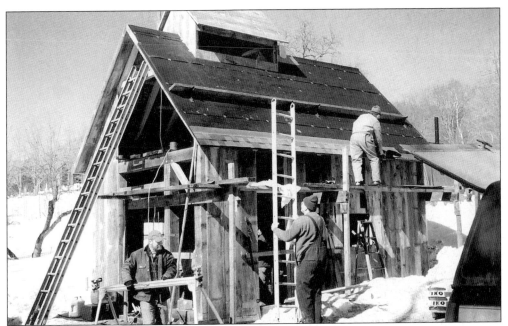

Jon Hartland of Enfield began building this post-and-beam sugarhouse in the winter of 2003–2004. As the sugaring season grew near and much work was still not done, neighbors lent a hand to finish the construction. Workers, seen from left to right, Rusty Keith, Phil Shipman, and David Hall work outside while and unidentified person works inside.

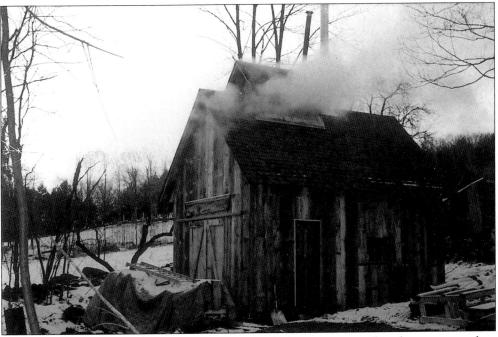

The Lakeview Farm Sugarhouse in Enfield was finished just in time and ready to operate when the first run of sap came. Jon Hartland had 123 taps that first year and made 43 gallons of syrup. The year 2004 was a good year for New Hampshire maple producers, with most making record amounts of high-quality syrup.

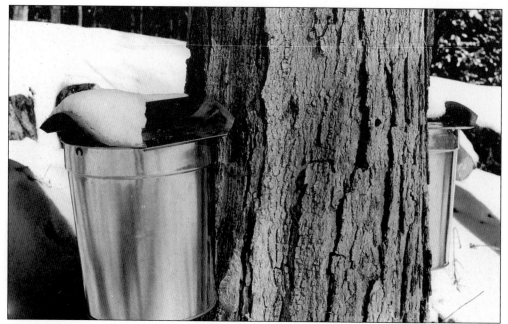

Shiny stainless steel buckets are gradually replacing the old English tin and galvanized buckets. Many maple producers use these new buckets for display purposes and when tubing is not practical. Stainless steel equipment is easier to clean, and its seams are welded or soldered with food-grade solder.

An unidentified youngster pours crystal-clear sap into a gathering tank. Sap from sugar maples usually contains 2 to 3 percent sugar, and some trees have up to 10 percent sugar. Red maples and box elders can also be tapped, but their sap has a lower sugar content and requires a longer boiling time to make syrup. Although Norway maples have a high sugar content, the sap bears an unpleasant flavor.

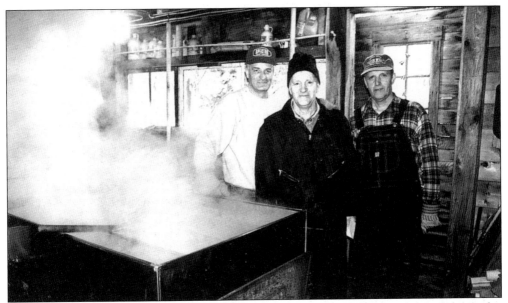

Workers at the Bolduc Farm sugarhouse in 2001 are shown here. Workers are, from left to right, Robert Hamel, Ernest Bolduc, and Armand Bolduc. This evaporator, built in the 1870s, was purchased by the Bolduc family in 1924 for $68.75. The original English tin pans were replaced by stainless steel pans in 1999.

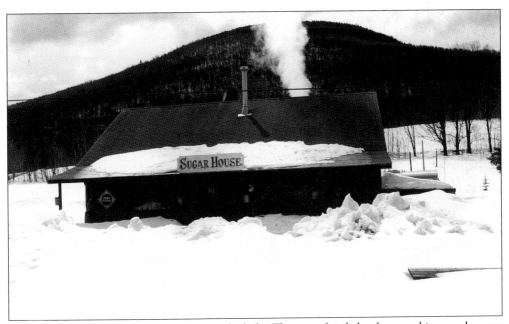

At the Mount Cube Farm sugarhouse in Orford, the Thomson family has been making maple syrup for about 50 years. Gov. Meldrim Thomson was the first New Hampshire governor to officially start off the maple sugaring season by publicly tapping a tree. The tradition continues today.

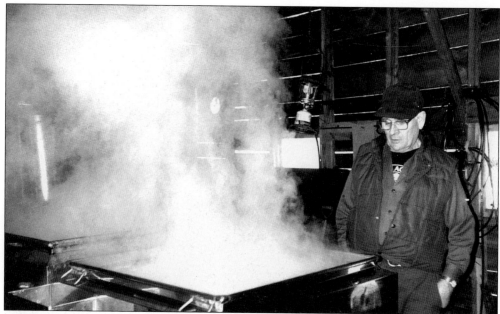

Robert Gray keeps watch on the boiling sap at Gray's Sugarhouse in Clarksville. English tin was once considered the ideal material for the construction of evaporators. When the dangers of lead solder became known, maple producers quickly changed to lead-free stainless steel equipment to protect the integrity of their products.

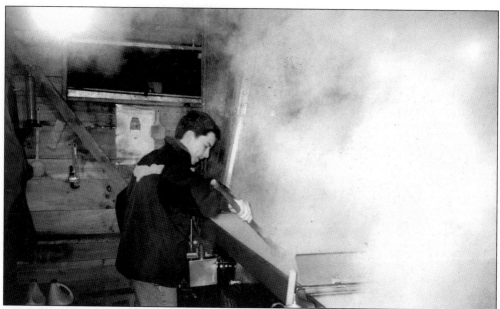

Alvaro Sales, an exchange student from Brazil, learned about making maple syrup at the Bolduc Farm Sugarhouse in Gilford. Here he uses a skimmer to remove impurities in the foam from the boiling sap. Maple sugar and syrup have been made on this property since 1779, and in the early years, farmers used maple sugar for barter.

A student at Proctor Academy in Andover hauls the gathering barrel to the next stop. When all of the sap is collected, it is trucked the few miles to the sugarhouse, where the students boil it down under the watchful guidance of their instructor.

Maple producers gather at Fuller's Sugarhouse in Lancaster for one of the many educational sessions held around the state each year. Keeping informed and sharing ideas on the latest developments, equipment, and methods of maple production is important to the producer.

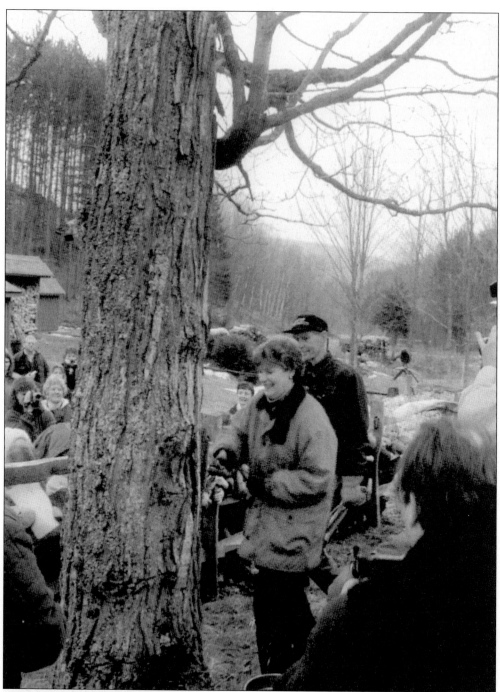

A crowd gathers in 2002 to watch Gov. Jeanne Shaheen use an old-fashioned auger to tap a tree, signifying the official start of the maple-sugaring season. Standing behind the governor is Bill Eva, president of the New Hampshire Maple Producers Association. The tree-tapping ceremony is conducted each year by the association and is held in various locations around the state. To help promote the industry and encourage people to visit sugarhouses, the governor also signs a proclamation designating one weekend in March as New Hampshire Maple Weekend.

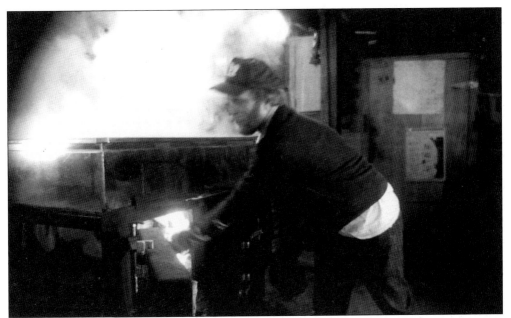

David Clark of Clark's Sugarhouse in Acworth stokes the fire under his evaporator pans. The elongated firebox, which holds the pans, is called an arch. Some maple producers now use oil to fuel their fire, while many continue to use wood. Modern airtight arches burn wood more efficiently, significantly reducing the amount of fuel needed.

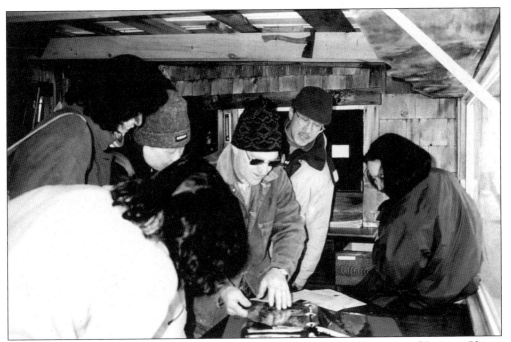

Each spring, Victor and Ruby Lam (right) bring students from the University of Beijing, China, to visit the Bolduc Farm in Gilford during the sugaring season. Ernest Bolduc (with sunglasses) shows photographs to his guests. The Chinese visitors enjoy maple syrup and hope to raise and tap sugar maples in China some day.

This collection tank is slowly filling up with sap. Sometimes a mile or more of plastic tubing carries sap to a collection tank before it is transported to the sugarhouse each day for boiling. Sap will sour if it is held too long or is not kept cold. It deteriorates as it sits, so the more quickly it is boiled down, the lighter the syrup will be.

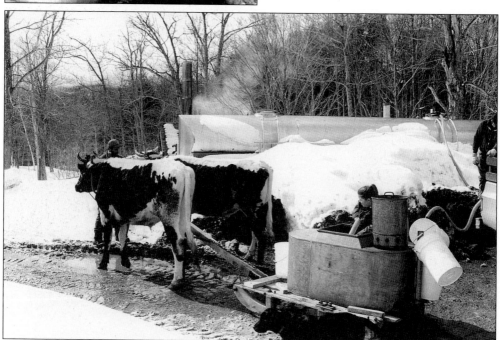

The holding tank for sap at this sugarhouse is a former milk trailer, seen in the background. An unidentified child holds the hose as sap is transferred from the gathering tank. Even the family dog seems to enjoy this springtime harvest. During a good sap run, the maple producer often works 12 or more hours a day collecting and boiling.

In most sugaring families, youngsters and old-timers alike help out any way they can. Here, eight-month-old Matthew Bean of Snow Farm in Wolfeboro cheerfully does his part. Passing down traditions is an important aspect of New Hampshire family life, and maple sugaring is one of the oldest traditions.

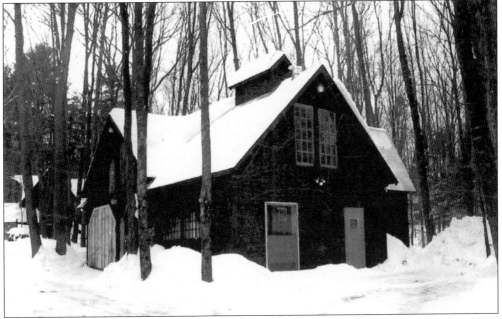

George and Winifred Corliss of Tilton built this large post-and-beam sugarhouse in 2001. Wooden shingles from different tree species cover the interior walls, and a maple tree carving adorns the new door that swings on maple leaf–shaped hinges. When a nearby producer became ill one spring, the Corliss family worked day and night boiling his sap.

When the maple sap is boiled down to the proper density to be classified as syrup, it is drawn from the evaporator, filtered, and bottled. In 1906, the U.S. Pure Food and Drug Act made adulteration of maple syrup illegal. Pure maple syrup is a natural product containing no additives or preservatives. Only water is removed to make it concentrated.

Favor Jenkins of Front Yard Sap Suckers sugarhouse in Wentworth pours hot syrup through a filter on a canning unit. This machine maintains the syrup at the proper temperature of 180 to 190 degrees for bottling. New Hampshire's syrup is packaged in plastic, metal, or glass containers, and most is sold to retail customers.

Roger Aldrich makes maple cream at Polly's Pancake House in Sugar Hill in 2003. Maple cream is made from pure maple syrup boiled to 235 degrees, cooled to 70 degrees, and then whipped to a creamy consistency. It is a delicious spread for toast or English muffins. Despite its name, there is no cream added.

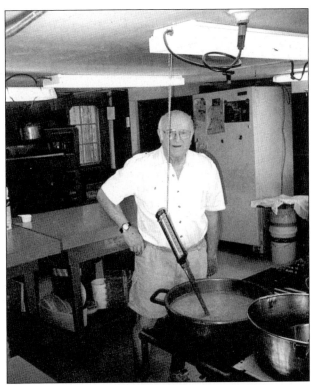

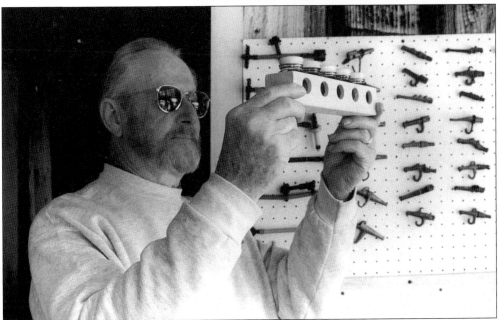

Harold Bigelow checks his syrup to determine how to grade it. New Hampshire syrup grades are Grade A Light, Medium, and Dark Amber, and Grade B. These are determined by the color of the syrup, with the lighter grades usually made in the earliest part of the season. As the season progresses, the syrup usually darkens slightly until, at the end of the season, Grade A Dark Amber or Grade B is produced.

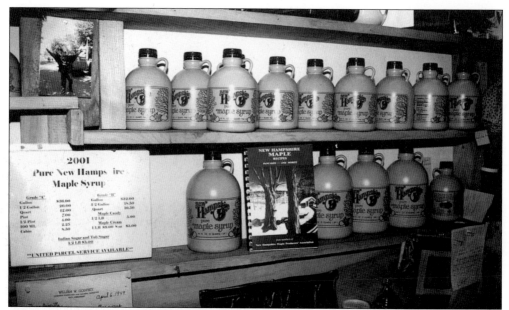

2001
Pure New Hampshire
Maple Syrup

Grade "A"		Grade "B"	
Gallon	$30.00	Gallon	$32.00
1 2 Gallon	20.00	1 2 Gallon	18.50
Quart	12.00	Quart	10.50
Pint	7.00	Maple Candy	
1 2 Pint	4.00	1 2 LB	5.00
100 ML	2.25	Maple Cream	
Cabin	8.50	1 LB $5.00 8 oz	$3.00

Indian Sugar and Tub Sugar
1 2 LB $3.00

"UNITED PARCEL SERVICE AVAILABLE"

After the syrup is deemed the proper density, filtered, and graded, it is then bottled into any of a variety of containers. In 1971, maple producer Charles Bacon of Jaffrey developed the first plastic containers made in New Hampshire. The Bacon Jug Company is still operating, but is no longer owned by the Bacon family. Charles Bacon contributed much to the maple industry and is a member of the Maple Hall of Fame.

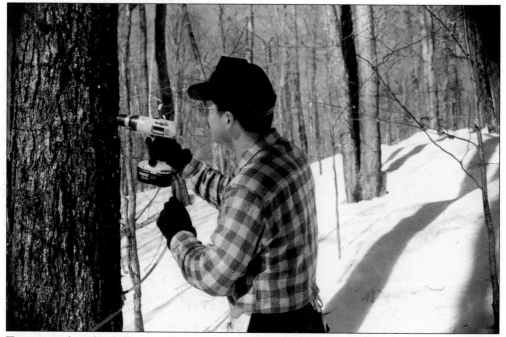

Tapping is done by drilling a 1¹/₄- to 1¹/₂-inch-deep hole in the tree. In 2001, an unidentified maple producer, with one hand holding the tubing and spile, uses a lightweight cordless drill. This unit can drill up to 100 holes on one charged battery. Spare batteries are carried so the worker can complete his job.

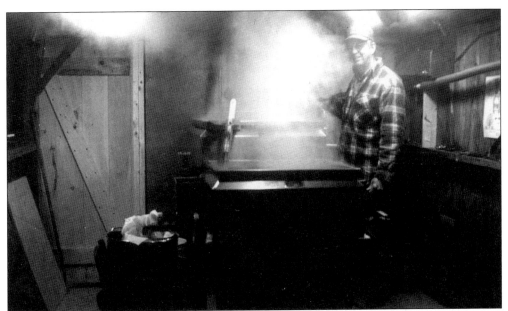

As with most maple producers, Don Lassonde of Beaver Meadow Brook Farm in Concord often boils late into the night to finish the day's run. Sap is gravity-fed into this back evaporator pan with the flow controlled by a float valve. Partially boiled sap later progresses into the front pan under the control of a second float valve. An oil burner provides a steady roaring fire to keep the sap boiling furiously.

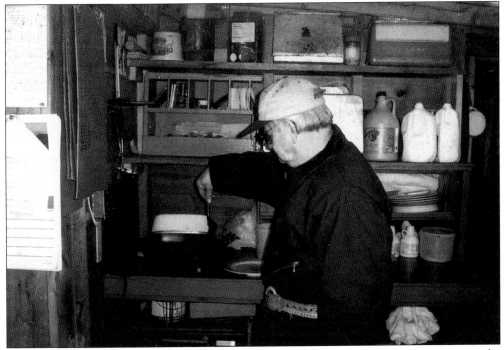

Ernest Bolduc cooks flapjacks for visitors at his Gilford sugarhouse. Many sugarhouses across the state offer pancake breakfasts during the sugaring season. Of course, pancakes are not complete without a good amount of pure maple syrup drizzled over them.

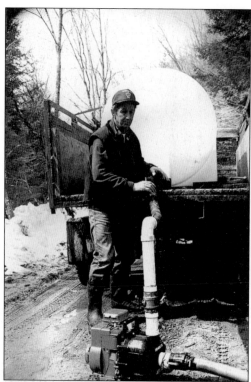

Paul Messer of Sunday Mountain Maple Farm in Orford uses a gasoline-fired pump to transfer sap from his truck to the holding tank in the sugarhouse. On a good day, he will collect up to 550 gallons on each trip. He makes about 700 gallons of syrup each year.

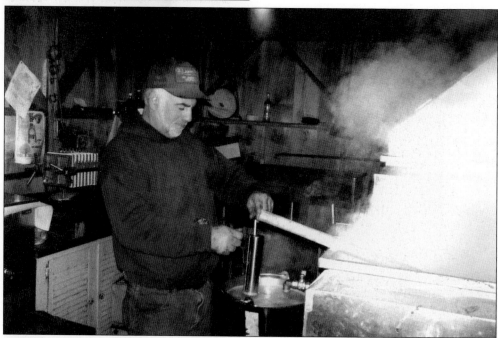

Keith Short of Short's Sugarhouse in Langdon tests his syrup with a hydrometer to ensure it is the proper density. Boiling hot syrup should register 59 degrees on the Brix scale or 32 degrees on the Baumé scale on the hydrometer. No mater what grade it is, all maple syrup is supposed to be the same density, making the sugar content the same in all grades.

Maple syrup is bottled at 180 to 190 degrees. It will keep well unopened at room temperature for years. Opened containers should be refrigerated to preserve the quality of the syrup. New Hampshire laws require that each syrup container must be marked with the grade and color of the product, as well as the name and address of the producer or packer.

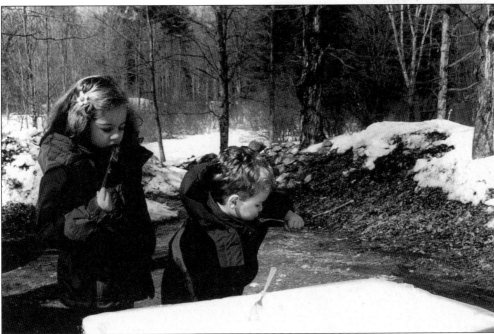

These unidentified children are enjoying sugar on snow while visiting a sugarhouse with their parents on New Hampshire Maple Weekend. Over 50 sugarhouses participate in New Hampshire Maple Weekend by welcoming visitors and offering guided tours, samples, and special activities. Some offer the experience of collecting the sap with horses or oxen.

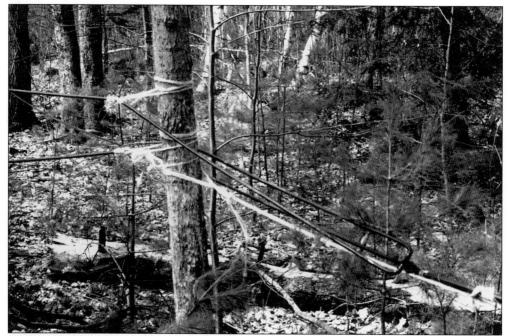

Plastic tubing stretches from one tree to the next, small lines feeding into larger main lines. Don Lassonde of Concord uses baling twine to keep his tubing tight and the sap running freely. Those producers who leave their tubing up year-round use wire cables.

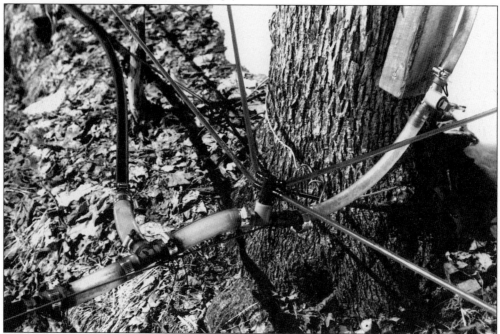

Small tubing from different areas of the orchard carry sap to larger tubing before the sap is piped to the collection tank. Improvements in plastic tubing since 1970 have greatly increased efficiency in sap gathering. New Hampshire now produces nearly twice as much maple syrup as in 1960, and many maple producers are able to handle all phases of the production alone.

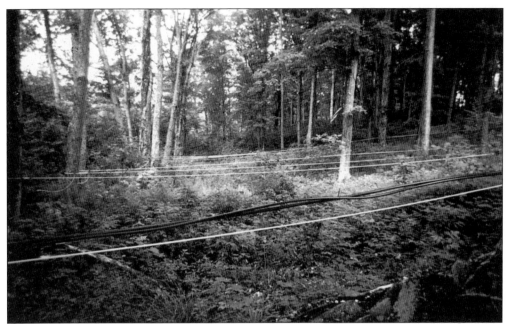

Here at Pearl and Sons Farm in Loudon, plastic tubing stretches down the hill. Maple producers with large operations such as this leave miles of plastic tubing in the woods year-round. The taps are pulled at the end of the season, and tubing is washed in place with a power washer, which mixes air and water for a scrubbing effect.

Small feeder lines, or laterals, connect to half-inch to two-inch main lines such as these, which carry a substantial flow of sap downhill to the holding tank. The normal downhill flow through these lines creates a natural vacuum in closed tubing. Modern vacuum systems hurry the sap along.

Five-year-old Tim Weinhold has a good view from atop the Bolduc Farm Sugarhouse in Gilford while elder family members boil sap. New Hampshire residents look forward to visiting sugarhouses after a long winter of confinement. The four- to six-week maple season extends from late February to mid-April.

In May 2002, high winds at Clark's maple orchard in Acworth uprooted trees and damaged plastic tubing. The maple industry is at the mercy of Mother Nature. The ice storm of 1998 wreaked havoc on the state's trees, destroying or badly damaging maple orchards around the state, and the hurricane of 1938 destroyed so many trees that the maple industry was devastated.

This airtight arch has a blower and a Steam-Away above the evaporator pans, all of which substantially decrease the amount of wood needed. With this unit, Dean Wilber makes 50 gallons of syrup with one cord of wood. Less efficient wood-burning units use about one cord to make 25 gallons of syrup.

Every maple producer fears ruining his pans by boiling them dry or burning the syrup. Sap boils down faster if shallow amounts are kept in the pans, but the risk of burning is greater in the front pan where the product is nearly syrup. Fortunately, Jon Hartland of Enfield was able to clean the burnt syrup from this pan in an hour using steel wool, sandpaper, and water.

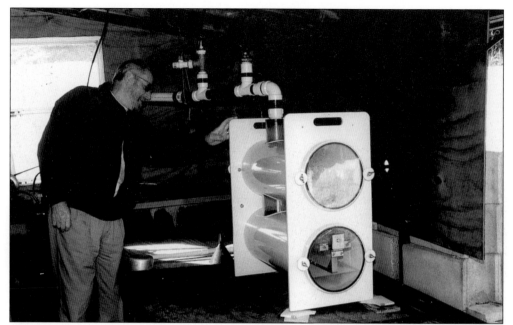

An unidentified man checks his automatic vacuum unit that pulls the sap through the tubing. Although it does not actually draw sap from the tree, a vacuum system increases a producer's total harvest, especially on days when the sap flow is weak. This system prevents backups in the lines and ensures a rapid flow of sap into the holding tank.

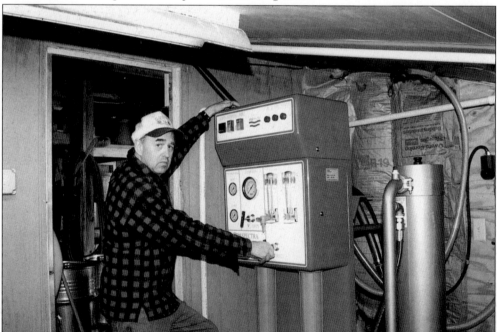

Peter Thomson of Mount Cube Sugarhouse in Orford sets his reverse-osmosis machine. First introduced in 1970, the machine became widely used by 1998. It removes 75 percent of the water from sap before evaporation, saving time and labor and reducing fuel consumption by 75 percent. Its use does not affect the flavor of the syrup.

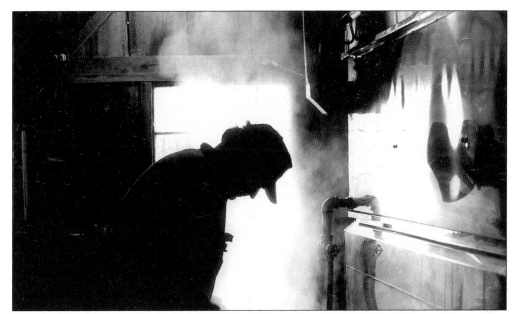

In 1985, the Piggy-Back was introduced to enhance the performance of the evaporator. This unit heats the sap and then injects air into it, causing rapid evaporation before the sap reaches the evaporator pan below. A similar unit, the Steam-Away, is also an energy-saving device that increases the boiling capacity of the evaporator by about 40 percent. This sugar maker is unidentified.

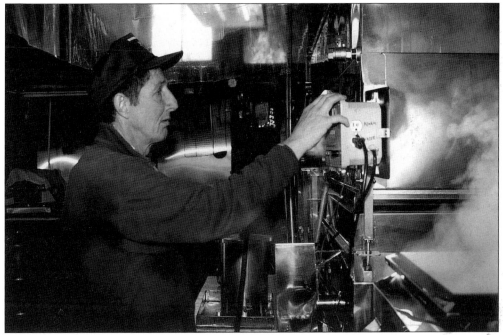

Stainless steel equipment helps to improve the cleanliness of a maple operation. Here, Paul Messer of Sunday Mountain Maple Farm in Orford sets the automatic draw-off control, which removes the syrup from the front evaporator pan when it reaches the set temperature. This invention helps prevent syrup from burning in the pan if the producer is distracted.

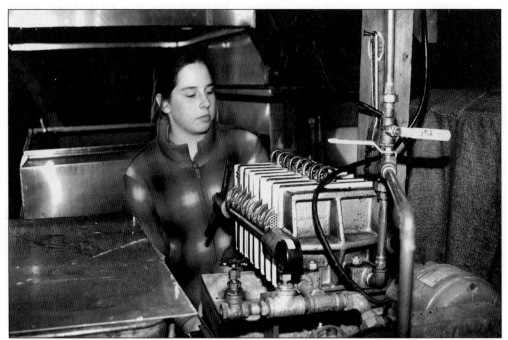

Sarah Bundy of Tomapo Farm in Lebanon keeps watch for leaks in the filter press at her grandfather's sugarhouse. The filter press forces syrup through a series of paper filters, removing all impurities. This machine can filter up to two gallons of syrup per minute and is widely used.

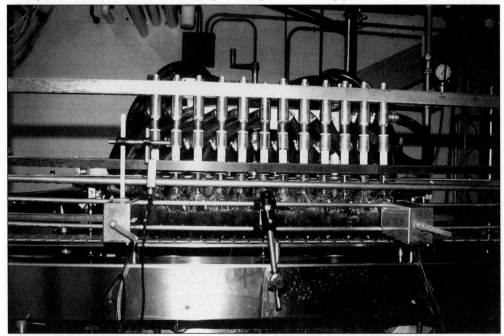

The bottler, or canner, is an invention used by large maple producers in recent years. This model fills a dozen containers at once, saving countless hours of labor. With many time- and energy-saving innovations, maple production in New Hampshire has rebounded from a low of 41,600 gallons in 1960 to nearly 90,000 gallons in 2004.

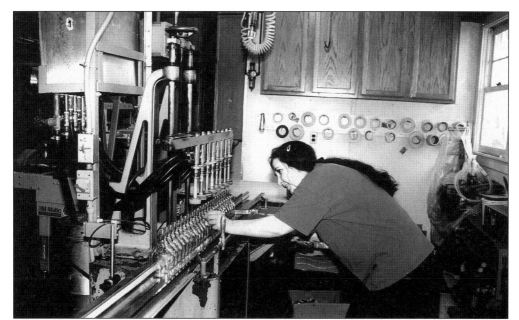

Heidi Bundy lines up glass bottles to be filled with maple syrup by this automatic bottler. Her father's Tomapo Farm Sugarhouse in Lebanon produces about 350 gallons of syrup. Those producing smaller amounts of syrup can purchase bottlers of a more appropriate size for them.

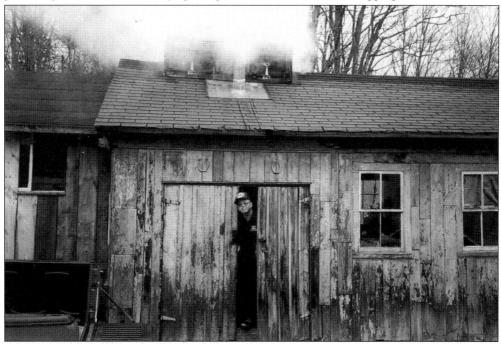

The end of the maple season is bittersweet for producers. Exhausted from long days and late nights of boiling with too few days to rest, the sugar maker knows he will miss doing what he loves in his little refuge. He will also miss the visits from other sugar makers who enjoy dropping in on each other whenever they get a short break. Here, David Holmes of Fitzwilliam appears sad that the season has ended.

Gerald Pease pauses briefly in the doorway of his Orford sugarhouse while members of his family scrub and rinse sap buckets in assembly-line fashion. Cleanliness is a key factor in making good maple syrup, and sugaring season is not over until everything is washed.

Tim Gowen and his son Blake of Acworth prepare to clean one of several collection tanks at their family sugarhouse. Because the Gowens no longer raise cattle, they have converted their large barn into an enormous sugarhouse. Several New Hampshire farmers have done likewise.

At the end of the season, if a maple producer is lucky, family members will help with the cleanup. All of the equipment must be washed and dried before being stored away. Here at Pease's Scenic Valley in Orford, gathering tanks and sap buckets dry in the warm spring sun. The Pease family has been making maple syrup for several generations, and Gerald Pease taps the same property his grandfather tapped.

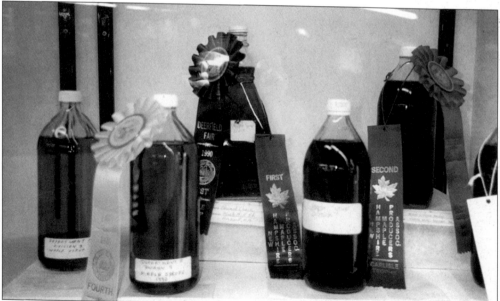

Many maple producers enter their syrup into competition at fairs around the state. These bottles of syrup at the Deerfield Fair are decorated with their prize-winning ribbons. Those entries that place first, second, or third at a New Hampshire fair are eligible to enter the statewide competition. Entries are judged on clarity, flavor, density, and color of the syrup, as well as cleanliness of the container.

Members of the New Hampshire Maple Producers Association use this portable sugarhouse to promote and sell maple products at various fairs around the state. Some fairs have permanent sugarhouses, including a large one at the Hopkinton Fair. Here at the Deerfield Fair, an unidentified volunteer waits for customers from the doorway of the sugarhouse.

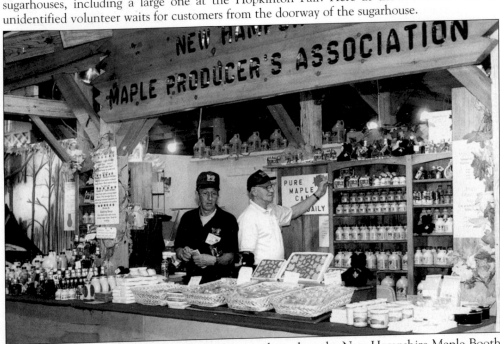

Paul Messer of Orford and Alvin Clark of Acworth work at the New Hampshire Maple Booth at Eastern States Exposition in Springfield, Massachusetts. An educational display and a wide variety of maple products are offered here. The New Hampshire Maple Producers Association consists of approximately 350 members and was organized in 1943 to promote New Hampshire maple products and keep members informed on important issues concerning the industry.

The Felker Award is presented by the New Hampshire Maple Producers Association in an effort to encourage youngsters to work in producing and marketing high-quality maple products. Each entrant must submit a project report. The 2004 recipient, Ben Fisk of Temple, poses with his award.

Each year the New Hampshire Maple Producers Association presents the Carlisle Trophy for the best maple syrup entered into competition. This award is intended to encourage excellence in maple syrup production and is named for Lawrence A. Carlisle, a well-liked deputy commissioner of the New Hampshire Department of Agriculture from 1921 to 1941. In 2003, association president Bill Eva presented the trophy to Don and Barbara Lassonde of Concord.

Bob Moulton of New Hampton (left) inducts his friend and fellow maple producer Roy Hutchinson of Canterbury into the Maple Hall of Farm in Croghan, New York, in 2003. Hutchinson has been active in the New Hampshire Maple Producers Association since 1960 and represented the state at the North American Maple Syrup Council. He built a sugarhouse for the Smithsonian Folk Life Festival in Washington, D.C., which is now a permanent structure at the Hopkinton Fairgrounds. He has also served as editor of the *Maple Syrup Digest* since 1990. Being inducted into the Maple Hall of Fame is the highest recognition a sugar maker can attain. Hutchinson is only the fourth New Hampshire producer to receive this honor.